Appalachian Lives

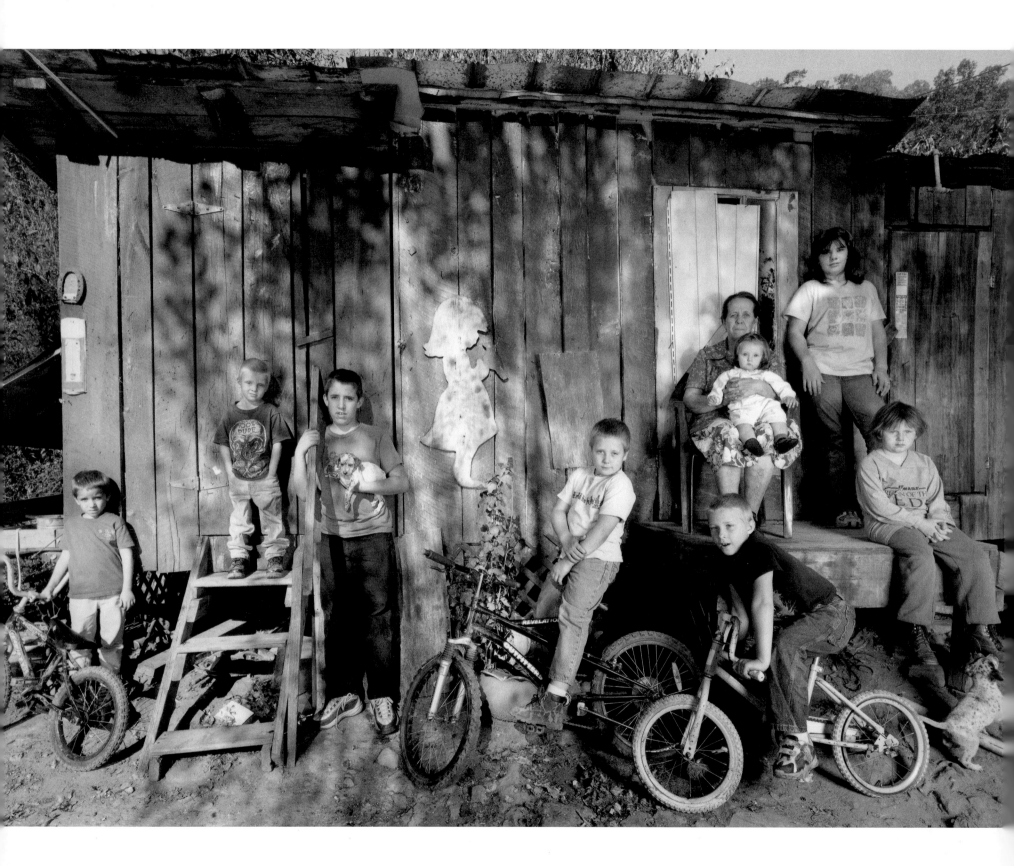

Appalachian Lives

Shelby Lee Adams

UNIVERSITY PRESS OF MISSISSIPPI JACKSON

www.upress.state.ms.us

The University Press of Mississippi is a member of the Association of American University Presses.

Manufactured in Singapore

Designed by John A. Langston

06 05 04 03 4 3 2 1

Library of Congress Cataloging-in-Publication Data

Adams, Shelby Lee.
 Appalachian lives / Shelby Lee Adams.
 p. cm.
 Includes index.
 ISBN 1-57806-540-2 (cloth : alk. paper)
 1. Appalachian Region, Southern—Social life and customs. 2. Appalachian Region, Southern—Pictorial works.
3. Kentucky—Social life and customs. 4. Kentucky—Pictorial works. 5. Mountain whites—Appalachian Region,
Southern—Pictorial works. 6. Mountain whites—Kentucky—Pictorial works. I. Title.

F217.A65A25 2003
978'.00943'022—dc21 2002013841

British Library Cataloging-in-Publication Data available

Frontis: Pairet with Grandchildren, 2000

Casecover: Dan and Flossie, 2001

To Anne Leaf,
Whose patience, understanding, love, and wisdom have now nurtured
this work for over twenty-five years

To the memory of Mimmie, Hort, and Henry Collins, Hooterville, Kentucky

Seeing

People walk the roads, but they can't see.

"It's" what anybody's thinkin' about, when they see somethin'.

"It's" only what you thinkin' is what you see.

Hort Collins

Hooterville

Acknowledgments

As always, I wish to thank my friends and subjects of Eastern Kentucky for their interest and support in the making of these photographs. Especially those Kentuckians who have traveled with me in the making of these photographs: Roy Banks, Richard Hall, Sherman Jacobs, Richmond Joseph, and Loyd Deane Noble. All have donated considerable time on my behalf; I will forever be indebted. Those recently deceased, may your memory always be preserved: Hort and Henry Collins, Bobby Hall, Darlene Jacobs, Bobby Newsome, Pete Adams, Berthie Napier, Jerry Riddle, Tilda Joseph, Jane Williams, Crow Caudill, and Cecil Cornett.

For counsel, regarding my work, career, and life, I wish to thank Andres Martin, John Max, Thayer Greene, Philip Volastro, Andrew Epstein, Wendy Ewald, and Eldred P. Davis. My gallery representatives, I wish to thank for their continued support: Stephen Bulger in Toronto, Cathy Edelman in Chicago, Burt and Missy Finger in Dallas, Vickie Bassetti in New Orleans, David Fahey in Los Angeles, and Yossi Milo in New York City. To the education department at the International Center of Photography, New York City, many thanks to Adam Eidelberg and Allison Morley for their continued interest in my work and teaching abilities. To the Peter S. Reed Foundation, New York City, my thanks for financial support during this time. To the many other friends, students, educators, museum curators, galleries, publishers, and collectors, my thanks for your interest and support.

To those who have actually helped me in the field making the photographs, working with my friends and subjects, collecting and editing their stories, I owe a special debt. Andy Hyslop, Ellen Rennard, and Larry Vonalt, each has contributed hours of labor and assisted me at different times. The memories of our working together have enriched my life and this work; for this, I am most grateful. Last, my appreciation to Seetha Srinivasan, director of the University Press of Mississippi, for publishing this—my third book. Thanks to Vicki Goldberg for her insightful essay and to John Langston, the book's designer, personal friend, and fellow connoisseur of fine photography.

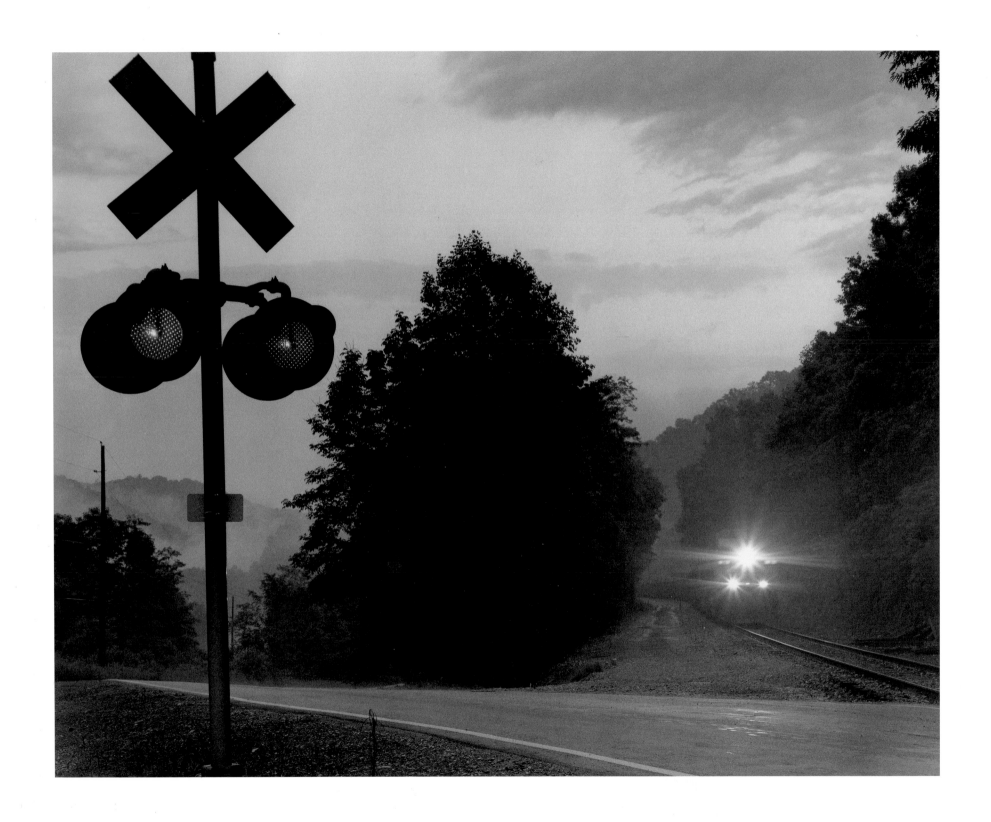

Beaver Gap 1998

Appalachia in Another Light Vicki Goldberg

The word "Appalachia" has a certain ring; it is the lugubrious sound of poverty and backwardness. For years certain hills and valleys around the Appalachian Mountain chain have been one of the poorest spots in America, until the very name of Appalachia has become synonymous with barefoot misery.

Nonfiction and some fiction writers, documentary photographers and filmmakers have repeatedly scrutinized the territory and, sometimes with the best intentions (which do not necessarily guarantee the best results), depicted a place where hard times wiped out the greater part of opportunity and hope, and even, sometimes, intelligence. Whatever substance this estimate has, Appalachians themselves, once they realized how it made the world regard them, resented it. The area became a site of touchy sensibilities, the residents hostile toward outsiders who came looking for Dogpatch. Some years ago, a man named Hobart Ison shot and killed a Canadian filmmaker who was taking pictures of his run-down rental property. Ison's neighbors were sympathetic; he remains a warning to hold up to intruders and in private he seems to be regarded with a kind of grim satisfaction.

Hobart Ison was Shelby Lee Adams's cousin. Adams's great-grandparents, grandparents, and parents lived in the Appalachian region of eastern Kentucky; he did too. His uncle was a highly respected local doctor. Adams himself knows a number of families personally or went to school with their relatives, and he will not approach anyone he does not know unless he has a personal introduction. Reference to his uncle generally makes him welcome; reference to his cousin Hobart always does the trick.

So, though he no longer lives there, Adams is a kind of insider. His father was in natural gas conversion and traveled all the time; Adams went to school each year in Philadelphia or Miami or some other city, but intermittently he attended the Hotspot Elementary School in Kentucky, and he spent a lot of time at his grandparents' farm.

Though he wrote in an earlier book, *Appalachian Legacy*, that "the mountains and its people are my lifeblood, and I must return regularly for a cleansing," he grew up with an ambivalent attitude to the place and its people. He was (and is) better off than his subjects. His parents would not let him visit the mountain people, saying they were inferior,

yet in high school children and teachers in the town school he attended looked down on him. In art school he was considered a hillbilly; ashamed, he did everything he could to dress like and sound like someone who had not grown up in Appalachia.

His photographs are in some sense a means of coming to terms with his own history, as well as a kind of history of life in Appalachia. Adams has been photographing this territory since 1974; this book is the third in a trilogy. It focuses on a new generation that, like every generation, looks different from the last. The young people, weaned on TV, dress in t-shirts that advertise products and sports teams and pop icons, with party dresses (but not party shoes) for the little girls. They have more mountain bikes than their parents did, and just as many puppies. Some houses are equipped with ceramic swans and cats, fake flowers and framed paintings. The owners may be no better off than their parents, but they are trying on whatever they can of the appearances of modernity and middle class life.

Adams works in ambiguous territory. He describes the people as loving and hospitable despite lives that have been unendingly difficult—mere girls become single mothers, a father has been known to kill a son or a brother a brother. Photographing the poor is an ambiguous enterprise to begin with, and critics are quick to point out its pitfalls. Add to all that the ambivalence Adams felt while growing up; perhaps a hint of that lingers too at the edge of certain pictures. At any rate, his photographs are at once intimate and distant, sympathetic and severe, respectful but tough, full of light and dogged by darkness, highly stylized yet capable of surprising candor.

It is safe to take Adams at his word when he says he is not a true documentarian but rather someone who cares about the people he photographs and makes subjective pictures of their relationships and the spirit of the people who live there. (Whatever true documentarians are, today they too would probably admit to subjectivity, for nothing and no one is deemed entirely objective any more.) Certainly Adams does not make "mere" documents or images meant solely to convey information. His pictures are theatrical, dramatic, posed and studied, inventive and experimental in their handling of space and light, clearly informed by a knowledge of art. The sense of composition—layered, complex, and demanding close attention—includes more extended families and more of their immediate environment than most Farm Security Administration photographers did and maintains more of a sense of order than the raucous contemporary reportage of someone like Richard Billingham.

Not that Adams has given up traditional ways of making portraits. He makes extensive use of an old-fashioned centralized frontality, sometimes with a subtle reference to traditional images of religion or rulership. There is the evident simplicity of the photograph of Peggy and Albert Campbell, a latter-day American Gothic with the couple sacralized by

the halo of their satellite dish; only a kind of wind blowing the dog and the two birds off to the right disrupts their ritual frontality. (Satellite dishes recur like a musical motif in these pictures, occupying yards as televisions occupy living rooms, solid signs that the need for entertainment follows hard on the heels of the need for food, lodging, and family.)

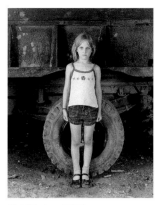

Bobbie Jo 2001

Even a child may be regarded with the confrontational seriousness that is natural to a view camera. (Adams uses a 4 x 5 Linhof on a tripod, which requires time to set up and doesn't lend itself readily to candid shots.) Bobbie Jo, smack in the center of the frame, is graced with a mandorla of sorts, formed by a truck panel behind her head and a mammoth tire behind the lower half of her body. *Eric*, a serious and unsentimental boy with deep lines beneath his eyes, stands just off center of the photograph and just right of center of a framed and somewhat sentimental picture of the suffering Christ. *Shauna Faye and Stephanie Lynn*, two pretty little girls all dressed up in dresses that are slightly too big, stand ceremoniously (if a bit awkwardly and plaintively) like queens before armchair thrones draped in bed spreads.

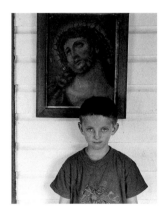

Eric 2001

Such formal portraits have a certain still solemnity (as do their subjects), no matter how ironically that is undercut by farm animals or kitsch. Much of the time, however, Adams plays such an elaborate game with space and light that the images have a slightly surreal or more than slightly mannerist edge. He slices space into thin sheets and arranges figures at varying distances within these tight lanes. Some of the players in these complex and enigmatic stage sets play secondary roles in subsidiary spaces, as if the set designer had needed reference points to maintain the illusion of distance. Elsewhere, in intricate plays of rushing and skewed perspectives, forms bulge out at us, often nudged by a wide-angle lens, or wait quietly to be discovered in some deep recess. Light comes from more than one place—Adams uses as many as five different light sources in conjunction with natural light—and lends an unearthly glow to some very earthly creatures.

Adams's control of space and light is elegant and ingenious and marks him off from other photographers of the territory. It also adds to the roster of ambiguities in his work, placing the residents of Appalachia in an artistic and indeed intellectual context that is just far enough from the norm to suggest that perhaps this is not such a simple and straightforward place—certainly this is not a simple and straightforward view of it—and that perhaps there is a degree of dislocation in these lives. Jacob Riis long ago emphasized the instability of poverty with compositions that violated the classical rules of the medium, and more recent photographers like Sebastião Salgado and James Nachtwey have employed all the disruptions and irregularities of postmodern composition in depictions of the poor and suffering. Adams's version is very much his own.

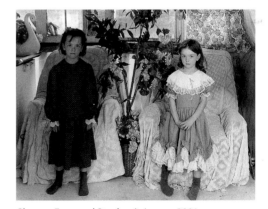

Shauna Faye and Stephanie Lynn 2001

In *The Old Home Place* (where no one has bothered to erase the graffiti), the house is

viewed dead on, but its symmetry is as precariously balanced on a junk-filled hill as the pictorial composition is between the satellite dish intruding at the upper lefthand corner, the dead branch extending a twig as if to touch the roof and the car nosing in at the lower right corner. The four people and a dog occupy three distinct planes in the shallow space of the porch, and the boy in the truck on the right is as small and far away as an afterthought.

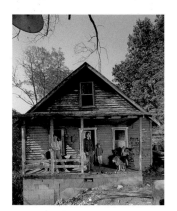

The Old Home Place 1997

Donnie with Baby and Cows, a sweet image of a man and those in his care, is also a tangled, vaguely surreal picture of figures that will not keep to their proper places or sizes. Everything pivots on a pole in the foreground, one of Adams's favorite devices, but what should recede on the right turns out to be a cow bulging out of the picture and staring at us. (I don't know if Adams tells animals about his cousin Hobart, but they watch the birdie as intently as ever their human beings do.) Another cow in the center glows mysteriously, the satellite dish that serves as a roof gives the man and child a royal, if scruffy, shelter, and a boy is discovered half hidden in the middle distance.

Elsewhere, families are grouped on porches with one member just inside the doorway of the house or seemingly far away in a distant room, like a view through a house in a seventeenth-century painting by Pieter de Hoogh. Or people stand a foot or so outside a window where family members inside are pressed up against the pane. House corners advance toward us with figures situated along the receding diagonal. Even at a funeral things slip away and the laws of physics grow deceptive: at *Berthie's Funeral*, the mourner appears to be upright and solemn but the coffin slides toward the right where everything is larger because nearer to us, and the flowers should by rights be easing their way slowly down the floor.

In *Driving Straight to Hell*, the driver who said that's what he's doing has been drinking beer no one else can stomach. His truck has a tapestry on the ceiling, an image of horses

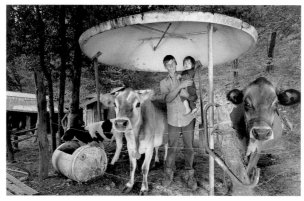

Donnie with Baby and Cows 1999

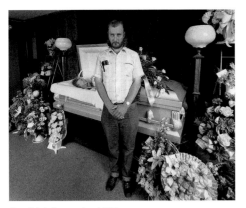

Berthie's Funeral 1998

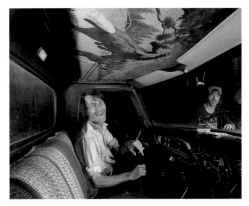

Driving Straight to Hell 1998

jumping that at this angle looks like a Mannerist painting, as distorted as any painting by Parmigianino in the sixteenth century. The space and lighting are as mad as the wildly laughing subject, with the truck's interior in close-up, splayed perspective; the flash picking out the seat back, the driver, the ceiling light, the tapestry, the white objects on the dash and a fellow at the hood who leans just enough to emphasize the angles of the shot. The happy driver is already comfortably ensconced in a cheaply upholstered hell.

Adams's light can play acrobatic tricks, or lovely ones. Back lighting puts haloes around the edges of heads of hair. Shadows fall in conflicting directions. Late sunlight graces the tops of trees and leaves hillsides in shadow behind brightly lit people. Houses gleam spookily, and people in murky spaces are softly illuminated.

He has a taste for incongruity, which in a sense is another form of ambiguity. *Rose Marie* poses against a mural in which the actual stove pipe is fastened onto a painted roof almost as if it were an inverted chimney. *Della Mae* stands with her guitar before a mural that has a clock hung on its sky and a real violin borne up by a flock of painted birds. And *Brother Baker*, who has a cross directly above his head, sits beneath a picture of Jesus, who is blessing a guitar hanging on the wall.

In the picture called *Shirley and Family with Moose Rack*, three people are framed by a construction that would be worthy of a modern geometric abstractionist; it's almost impossible to decipher the whereabouts of the triangle and trapezoid at the left. But this updated modernist has not only added figures and toys—and mess—but a heart that sprouts moose antlers, as if Richard Diebenkorn had been crossed with David Salle.

And on occasion this world threatens to fall apart, a metaphorical threat that the shaky houses and finances, as well as certain family histories Adams recounts, suggest can be very real. In *Hooterville at Dusk*, the center does not hold. The shack, eerily illuminated as the light is leaving the sky, tilts drunkenly to the right, and the car's windshield wiper points off to the left as if in answer. The overhead wires make illogical traffic patterns and the

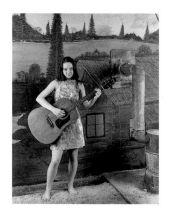

Rose Marie 1999

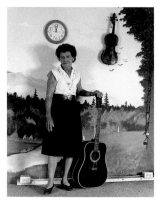

Della Mae 1999

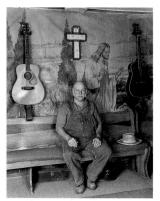

Brother Baker 1999

scraggly tree leans way out of the picture, sending its branches back in steep curves that imitate the handle bar of a fallen bike. In a moment caught by a camera, a moment we are well aware lasted less than a minute, even solid objects seem like temporary apparitions that will vanish as soon as the shutter snaps closed.

Adams's Appalachia, as suffused with *gravitas* as with disorder, as entwined with family as it is burdened with hardships, is also a place of measured distances and elastic spaces, unpredictable light and formal intricacies, a place almost as full of the complications of art as it is of the complications of life.

The poor have always been with us, but for a long while artists did not pay them much attention. They have been depicted now and again at least since Hellenistic times, but it was not until the nineteenth century, as ideas about poverty were changing, that artists began to consider their condition and its inequities with sustained seriousness. (Think of Daumier's third-class railway carriage passengers or Degas's tired laundresses.) By the second half of that century, as industrialization and urbanization produced miserable conditions for masses of people and made them increasingly visible to more solid citizens, prominent writers like Dickens decried the slums and degradations of the industrial era. The widely held notion that the poor were lazy, drunk, and wholly responsible for their own wretchedness began to give way to the realization that society and social conditions must accept a share of the blame. Photography swiftly moved into this territory and eventually proved its prime illustrator.

The real starting points were reform campaigns. In America in the 1890s, Jacob Riis discovered that photographs were even more convincing than the newspaper reports he wrote in his crusade against the tenements in New York. Early in the twentieth century, Lewis Hine photographed child labor in a campaign to pass laws to protect the young. In the 1930s, the Farm Security Agency photographers photographed the rural poor in order to win the support of the urban middle classes for President Roosevelt's farm policies. Throughout the last century, the poor have been a continual source of fascination for photographers, whether in the service of organized propaganda or journalism, private documentary projects or even more purely photographic programs like street photography.

It's a sure bet that people photographing the poor are better off than their subjects, who don't have the kinds of protections the middle and especially the upper classes build around their private lives. The land of poverty is difficult territory for photographers and viewers alike, for it's hard to beat down the guilt of having more and not doing enough, and the guilt that dogs the voyeuristic impulse. Photographic critics in the last twenty or thirty years have made it even more so, decrying every perceived insult to the self-worth

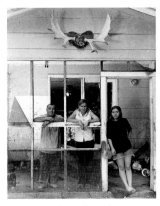
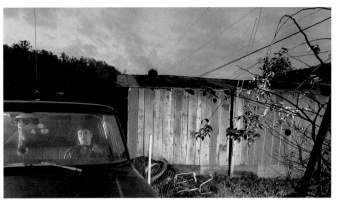

Shirley and Family with Moose Rack 2000

Hooterville at Dusk 1997

of the humble and contributing heavily to a wave of resentment against photography, its infractions and its invasions.

Like many another who photograph the poor, Adams has been accused of exploiting his subjects. Exploitation is a moral term without strict boundaries that changes with changing social attitudes and often takes different shape in individual minds. Being at least half an insider, Adams is in a better position to defend himself than most photographers. His closeness to his subjects has even increased over time; he says he loves these people and that they have empowered him spiritually.

There can be no question that he does everything humanly possible to give his subjects some power over their pictures, that they have cooperated with him entirely, and that they are pleased with the results. He discusses his ideas for pictures with them before he takes them, gives them Polaroids and when he returns the next summer brings prints. He obtains signed consents before publishing, and his pictures often end up framed on their walls.

Still, the moral dilemmas that shadow photography, which has an inherent transgressive streak, are not easily eliminated. While Adams works at sidestepping stereotypes and minimizing the inequities between photographer and subject, neither will quite disappear. And in fact, some of photography's most compelling moments by photographers like Richard Avedon, Diane Arbus, William Klein, Lisette Model, even Walker Evans and Robert Frank, have achieved their force at least partly at their subjects' expense. If anyone tells you the world is a just place, tell them you have a bridge you'd like to sell them.

For my part, evidence of Adams's care and respect shines through in the sympathetic nature of most of his pictures once allowance is made for his refusal to shy away from the facts of his subjects' lives. (I am reminded that Salinger titled one story, "For Esmé with Love and Squalor.") It is true that there are images here it is hard to imagine meeting with their subjects' approval, including the fact that some people have been shunted off into

a distance where they are close to invisible. Perhaps this difficulty means we do not fully understand how these people relate to whatever life has dealt them. It might be more flattering to disguise the price life has exacted in Appalachia, but to what end? What Adams has registered in many photographs is more important than flattery: dignity, close family ties, and moments of shared gaiety.

There are those who think it is wrong merely to photograph the physically and mentally disadvantaged; Adams does not. This is a thorny matter far beyond photography, and if the alternative is simply erasing such people from view, that is certainly not a solution. One particularly taut picture, *Selina in Living Room*, conveys the explosive nature of the issue without slighting Selina's humanity, or her brother's. The room is seen as an irregular diamond with us positioned at one apex and Selina turning forward into our space. The seated figure of the father, his face directly above Selina's, anchors a composition that might otherwise fly apart and burst out of its peculiarly stretched perspective. The four faces, including the television—there are actually six, if you count the two pictures—make another diamond shape on the surface, though Adams has once again sliced the space into narrow planes, the bearded man being slightly behind his father. The pictorial distortion may echo the uncommon nature of life in this family, but the photographer has hardly been unkind.

Adams looks at a difficult subject with an artist's eye. At their best, the complicated and ambiguous pictures in this book are an uncommon blend of humanity, reportage, and art, an Appalachia most of us thought we knew seen through eyes that tell us that maybe we didn't know it so well after all.

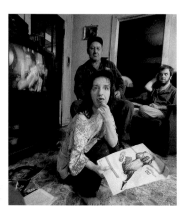

Selina in Living Room 2001

Making Photographs

To make a good photograph in the formal manner within intense family environments, the way in which I'm used to working, you set up all the elements and hope for the best. If you were to try and force an expression from your subjects, to make them respond in a certain way to give you what you really want, you would run the risk of ruining everything. You've just got to let it unfold. Observe life as it happens. You step back and let it happen. "It" has to come of its own accord. You seize the moment of making the photograph in the way only you see the world. This is the practice I have learned to master.

—Shelby Lee Adams, April 2002

I am often asked how I do my work. I have been returning to Kentucky, my home state, for thirty years now, photographing for about three months a year, and I suppose a pattern of work has emerged. For me, the process is intuitive and emotional, although it is at the same time based on a formal understanding of the visual and literary arts. With my equipment and films packed in the car, I start out each day. As I drive through the mountains, sometimes over great distances, I decide where I will go. Perhaps I work somewhat like a painter who mixes his palette with specific colors to create different concepts, moods, and effects. My photography is made in a similar manner to express something of myself, light being my most expressive tool.

Although I am working within a single culture, a culture in transition, I am also collaborating with unique individuals, families, and communities. I must know, understand, and be accepted by a range of people. Often, these relationships have developed over a period of years, so that, before I make my photograph, I have established a strong rapport with my subjects. I sometimes visit without the intention of taking a picture, only to have the idea of a particular photograph emerge in the moment or later as I reflect on what I have observed. What makes my work unusual is that the hours of traveling and visiting are just as important as making the photographs, which are expressions of my love for these people and this place.

Before the mid-eighties, when I returned to Kentucky I always lived in the area of my home, Letcher County, and traveled from there to photograph my immediate family, childhood acquaintances, and neighbors. This early work was more formal and academic, influenced by my education in the visual arts. I was seeing from an insider's point of view, shaped by my own personal history. Then I began living in the community of Leatherwood, Kentucky, and my work went through some significant changes. Even though Leatherwood was only thirty miles from where I had grown up, being immersed in a new Appalachian community gave me a better, broader understanding of the culture. Also, I had experienced a fall which caused a major nerve neuropathy that kept me from walking for over a year and otherwise limited my physical activity. My subjects frequently saw me resting on a porch after a shoot and had to help me carry my equipment. They knew my determination to continue photographing them. My awareness of my own physical vulnerability gave me deeper empathy and a greater understanding of the fragility of the human condition.

When I lived in Leatherwood, people whom I had photographed would come to see me in my small apartment, arriving unannounced, just as I would drop in on them to visit and photograph. They were curious about me. My books were the subject of conversation. Who were William Blake, Nietzsche, and Jung? They told me the Bible was the only book of importance, and we discussed religion. Everyone looked at the photography books I'd brought, from Richard Avedon to Robert Frank. Most liked Avedon's work best because of the details in his photographs. People often asked me to drive them to a doctor's appointment or to the grocery store because they had no car. They would ask me to help them fill out government assistance and medical forms. I learned more about the reality of their lives and how they saw me. Because my door was open to them in those days, I became able to see them more clearly and with more compassion. An academic approach was simply no longer possible for me.

People in Kentucky have often asked me why I bother doing what I do, and at first many assume I am from New York or Boston. When I accompanied a Holiness serpent-handling preacher to a hospital for the treatment of a serpent bite, the doctors thought I was a social anthropologist. When I first photographed in Beech Fork, Kentucky—a hollow transformed into a coal mining processing plant—people there mistook me for a mining company surveyor. These misunderstandings have often been the beginnings of conversations that have led to my acceptance by the community. Now people say, "He's the one that does them picture books, you know, the picture man."

My way of setting up and making photographs has varied a lot over the years. I used to ask people to look into the lens of my camera and find their own image in the reflection of the glass. At the moment of self-recognition when they saw themselves in the large

Richmond's Ladder *1999* **xix**

Aunt Glade with Tom 1973

view camera's lens, I would make the photograph. I felt that this approach made for a less self-conscious photograph. Today, I just ask them to look at the lens. The environments and people I'm attracted to change all the time, but I have become more selective in choosing subjects. Over time I have developed an aesthetic that influences my feeling about who will give me a good portrait and what is authentic.

 I have photographed some people repeatedly over a period of twenty-five years, each time getting a genuine engagement. In other cases I have met someone for the first time, set up my camera, taken a photograph, and then continued to visit and photograph the person for another twenty years without ever making another compelling portrait. It's as if some people have waited a lifetime to be photographed and then have only one moment in which to give themselves fully to a photographer. I may become their friend for life and continue to photograph them but without ever again getting striking results. Still others are people I have known for years but not photographed because they weren't visually interesting to me, until one day, suddenly, I am visiting and see them as if for the first time—something radiant or tragic has come alive in them, and I am able to make a memorable portrait.

Grandpa's Chair 1971

In all cases, what matters to me is the quality of my relationships with those I photograph. I have come to understand that people give to each other in many different ways and that I have to be responsive and open-minded to keep a clear and persistent vision. At the same time I know that my subjects want to be photographed. They enjoy the process; they like the pictures and the attention I give them. Some people have requested that I photograph their funeral when they die, a tradition that is still practiced here and an invitation that I consider an honor.

Because I am an environmental photographer, the setting of a portrait is very important to me. In the beginning I was influenced a great deal by my academic background in the history of photography and the history of painting, but in the mid-eighties I began asking my subjects where they would like to be photographed. Their responses brought a collaborative spirit to the work, and I became more understanding of how people viewed themselves. At the same time, because they often wanted to be photographed in places where the lighting was poor, I was faced with new challenges. In 1986 I bought my first strobe light kit, which not only allowed me to photograph in a greater variety of environments but also expanded my time out in the field, as I was no longer totally dependant

on daylight. Today, I work with as many as five different artificial lighting sources, usually in combination with daylight. For me, the mixing and blending of daylight and strobe has become an aesthetic choice as much as a technical necessity.

My work is subjective, creative, and personal. Although it is not intended to be an instrument of change, it has taken place during a unique time, a time of great transition within the Appalachian culture. The photographs do reflect these changes—T-shirts with logos are now worn instead of overalls, mobile homes have replaced log cabins, Primestar cable has supplanted TV satellite dishes. In the seventies I traveled on narrow, two-lane, black-topped country roads; today, I also drive on four-lane divided interstate highways. Yet even as the culture changes and my own work evolves, the relationships endure. What keeps my work vital is the mystery of never knowing what I'm going to encounter. What makes all of it happen is the interaction and collaboration between subject and photographer. In making my photographs, I observe life, question reality, and emphasize particular details without ever really knowing for sure what my subjects are thinking or feeling or doing. The extended portrait is my effort to create and record, though I am still only guessing at what is really before me.

Knowest the hearts of children.

—LAMENTATIONS 4.4

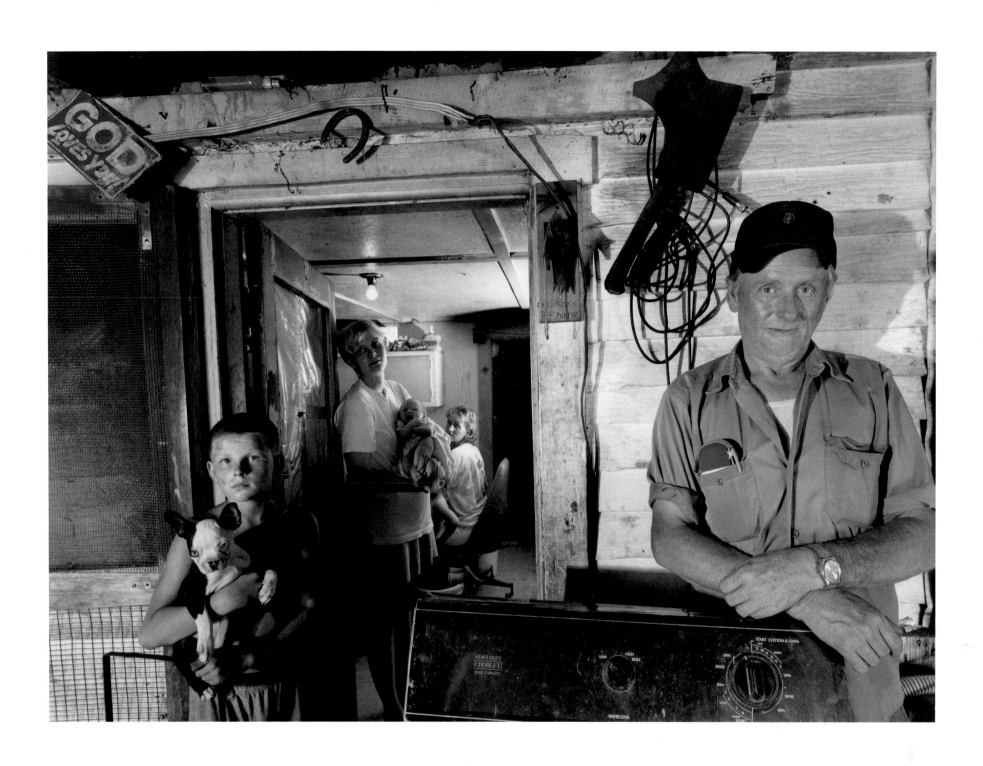

Sherman's Porch 2001

To get to Sherman's place, you drive a few miles on a two-lane, curvy, black-topped country road, past Seco and the Neon water plant. As you drive around one particular horseshoe curve and look at the mountain to the far left, you can see Sherman's place, if you know where to look. Going from west to east, the route I usually take, you pass by Sherman's drive, since the turnoff is only accessible on the creek side of the road. You have to drive into Neon Junction, turn around in front of the fruit stand, and go back in order to reach Sherman's drive on the far right. The road, dropping sharply, becomes dirt and gravel, then turns onto a one-lane railroad bridge with three-foot-high stainless steel supports on both sides. You drive over old wood slats that have come loose from the flooring of the bridge and that make funny popping sounds as you cross them.

Once across the bridge, you see along the side of the road several trailers with unturned gardens, satellite dishes, and parked cars. The road, bearing to the left, steepens and narrows as you climb the mountain, and when you top it and level out, turning a sharp right, the vista opens immediately into a wide expansive space. The mountain top is covered with automobiles, pickup trucks, engine blocks, car parts, and old tires. In the background you can see the old home place where Sherman has lived with his family for the last ten years.

I have been visiting and photographing Sherman and his family since the 1980s, and they appear in both of my books. Sherman is in his mid-fifties, and he and his wife, Hermie, have five children—Sally, Michelle, Bruce, Odis, and Barbara. Most of the children have married, divorced, and remarried, and they, along with their spouses, their own children, and their friends, all visit at Sherman's. Sometimes children and grandchildren stay with Sherman and Hermie intermittently. With all the children playing about the yard and house, the place can seem chaotic, but there is nothing chaotic about Sherman. Deliberate and knowledgeable, he is a caring father and grandfather and a friend.

When I talked with Sherman about my new book project, he agreed to tell me stories about his life to accompany some of his family's photographs. I asked him how he made a living, and he responded, "I basically buy junk cars, fix 'em up and resell 'em. I learned car

work on my own. When I was sixteen years old, I started workin' on cars. I'd take a car apart. I'd watch what I was doin', every piece I'd take off. I'd mark it with a piece of tape and chalk it. A 1952 Chevy pickup truck engine was one of the first I ever worked on. When I'd find a broke part, gasket or something like that, I'd take it to the parts house, trade it in on a rewelded part or a new one, until I got it right to running. I marked every part I took out of an engine and put it back, until I had 'em pretty well memorized.

"I worked on and owned a Golden Hawk Studebaker, '50s model, registered for 160 M.P.H., two-barrel carburetor. I loved it, but it got to where I couldn't get parts for it and I sold it. Then I got a '54 Cadillac convertible. I always had to work on 'em myself. At that time, I couldn't afford nothing. I was lucky I had a car then. We used to drag race, I'd race with a De Soto, way up late in the night, we'd drag race until 1:00 A.M. in the morning. We'd pair off two at a time. They've been many a time, sometimes, you'd slide plumb out of the road into some farmer's bottom. One time, I owned a hand-cranked Model A Ford; it back-cranked and knocked me over, and I got mad and sold it for fifteen dollars. We didn't drink and drive then. Even a sober person had a bad time on these roads then, if they weren't careful. Back then, there weren't that much traffic."

Sherman learned how to play guitar the same way he learned how to repair cars—on his own. "I learned to play music watching TV. Watched the Porter Wagoner show with Grandpa Jones. I picked it up watching and picking. The Carter Family played the 'Wild-wood Flower' and I learned that. Years later I played music with the Carters in Virginia. I met June Carter and let her play my guitar. My guitar was from the '50s, the one they got started out with. We played bluegrass and country, 'Little Maggie,' 'Pretty Polly,' and 'Coal Miner's Daughter.' I could play Conway Twitty songs and George Jones songs like 'Worried Man Blues.' Started out playing on Kay guitars, went on to Harmony, Gibson, and later to Yamaha."

When I asked him about the pistol he wore, he said, "I carry a .38 caliber Charter Arms, and have for over twenty years. It's sighted and holstered on my right hip. By Kentucky law, as long as a gun is in sight it's legal to carry one. In your car, you take it off, lay it on the dash, and you can travel that way. If you put a gun in the glove box or under the seat, it's considered a concealed weapon and you can be arrested. In fact, your gun can be taken and you can be thrown in jail. When you cross the state line into Virginia, your gun must be locked in the trunk and shells in the glove box, because my license and home is in Kentucky. I consider it my right to carry a gun. It's not to harm somebody—it's to protect me by the looks. If someone sees you with a gun by your side, they not goin' to bother you. As long as you don't have a jail record in Kentucky, they can't stop you from carrying one."

Medical care is often a problem for mountain families. My uncle Lundy was Sherman's family physician for many years. "Back in the old days when one of the younguns got sick,

Doc Adams always took care of you," Sherman told me. "It didn't matter if you had money or not. I've been in the hospital many a time and sat from 1:00 A.M. until 6:00 A.M. before seeing anybody. The nurses come out and tell you it will be two or three more minutes and you sit there for two or three more hours. We don't have no medical card or insurance and we can't get good service in a hospital. I remember a young boy in the waiting room at the hospital one time tellin' a nurse, 'I didn't come here to get a fix.' They treat you sometimes like that was what you was there for."

Sherman's daughter Sally was in a serious car accident in 1995. She was thrown through the windshield and nearly died. She still has some shreds of glass lodged in her right cheek, which you can feel when you touch her face. The doctors never removed all the glass from her face because she didn't have coverage for plastic surgery, and they told her that getting it all out was not necessary. Sherman has a police scanner in his kitchen, which he keeps on all the time, especially when his kids are out on the road. He said, "I worry about the kids, and listen in case one of them was in a wreck. If you ain't got a scanner or CB and live in the country, you don't know anything about your people."

On my last day to photograph in the summer of 2001, the air is clear and the sky is beautiful. I decide to go to Sherman's. I know there will be ten or fifteen kids to photograph, plus all the pets and a particular rooster named Spike I am interested in. I know how the light will be around the farm at different times of the day. As I drive, I begin to compose the photographs in my head, as I often do when I have a long trip to make. I select the backgrounds, subjects, locations, lighting equipment, camera, lens, place, and position as much as possible in my mind's eye, and I also get ready mentally for the possibility of chaos, in which case all my ideas could fall apart.

When I arrive at Sherman's around 1:00 P.M., several cars are parked in the drive. Kids are running around everywhere. Some of them dash up to me as I get out of the car, saying, "Did you bring me anything?" I give out some gum and candy and take a pack of cigarettes to Hermie, who sits on the porch. I ask her if it is okay to set up my camera and start taking pictures in the yard with the kids. "Yes," she says, laughing, "if you can stand 'em all running around."

I get two of the boys to go back to the car with me to help unload some of the equipment and carry it to the chicken coop. We get my 4 x 5 camera, tripod, extension cords, ice cooler containing film and Polaroids, a 2400-watt light pack, two strobe lights, umbrellas, light stands, bottled water, tape for Polaroids, and my reading glasses. I begin setting up my camera in front of the chicken coop where Spike the rooster is kept.

For this picture, I've selected Eric to be the subject holding the rooster. When I get my

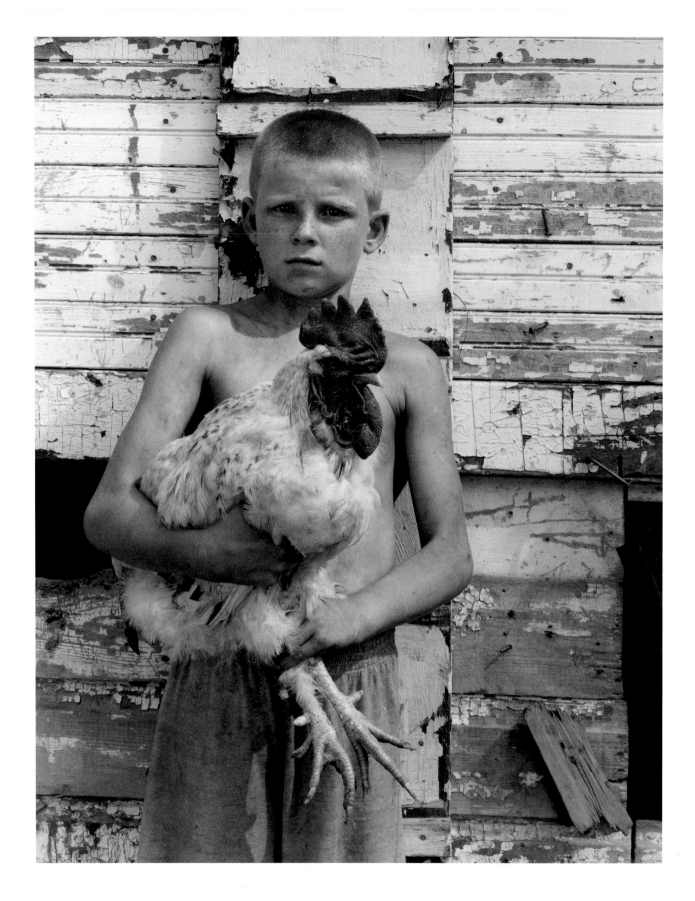

Eric with Spike the Rooster 2001

lights set up and camera adjusted, all the little boys run up, wanting to be photographed with the rooster. The wind on top of the mountain begins to blow suddenly. We have to grab the lights and hold them. "Get some brick and rocks or blocks of coal," I yell to some of the boys, "to hold these lights down." As it turns out, Eric is the biggest boy and the only one who can actually hold the rooster still without getting scratched.

A ruckus breaks out among the boys over who is going to have his picture made first. The sun is very hot; white clouds are moving in and out of the light. Some of the boys get bored and start riding their bicycles all around my equipment, splashing mud over the electrical cords. I shout toward the house, wanting someone to come out and get the boys away from my equipment. Sherman's son Bruce comes out, yells at everyone, and then goes back inside. From the front porch, Hermie starts to watch more attentively, laughing at us all. Eric's attention span is waning, and the rooster is getting squirmy and difficult for him to hold.

As I make my first Polaroid, a cloud covers the sun, so the picture is flat and difficult to judge. We wait five minutes for the clouds to clear so I can make my exposures. I feel tense, exasperated, and isolated, surrounded by a dozen screaming and rambunctious children. The kids are restless, fighting with each other and yelling, and I must shoot film soon or the composition will fall apart. Finally, the sky clears and I shoot immediately, having time to make two negatives before the light changes again and Eric can't hold the rooster any-more. I make one last Polaroid, but the light has changed already; I'm not sure whether I got the photograph or not. Sometimes I hate working in daylight, because it is so unpre-dictable. For this photograph, I have been trying to balance the daylight with strobe and get a good response from Eric and the rooster.

The wind is blowing harder, the sun is hot, and the kids are making a racket. I laugh to myself, wondering if I'm having a good time yet. Looking in the opposite direction, I see that the back porch is in total shade. I decide to move my equipment about six feet, so I will be in the shade and cooler, and can then be photographing toward the back porch. After about a half hour rearranging, I see the image I want to make. I place my wide-angle lens on the view camera and move even closer to the porch. All the boys still want their pictures made with the roosters and chickens. I have several of them get up on the porch with the birds. I make some Polaroids to give to the kids and expose some negatives so I can make prints for my next visit. An old dog comes out from under the porch and bites one of the little girls who is standing about. She screams. Everyone comes over, and I tell the family which dog bit the little girl. The boys are told to drag the dog away from the house, which they do immediately, hitting at it with firewood sticks. Another dog attacks the old one; a fight erupts, and the animals have to be separated. Someone says, "That old dog was set out here last night. He ain't no 'count. We didn't know that he was like that!"

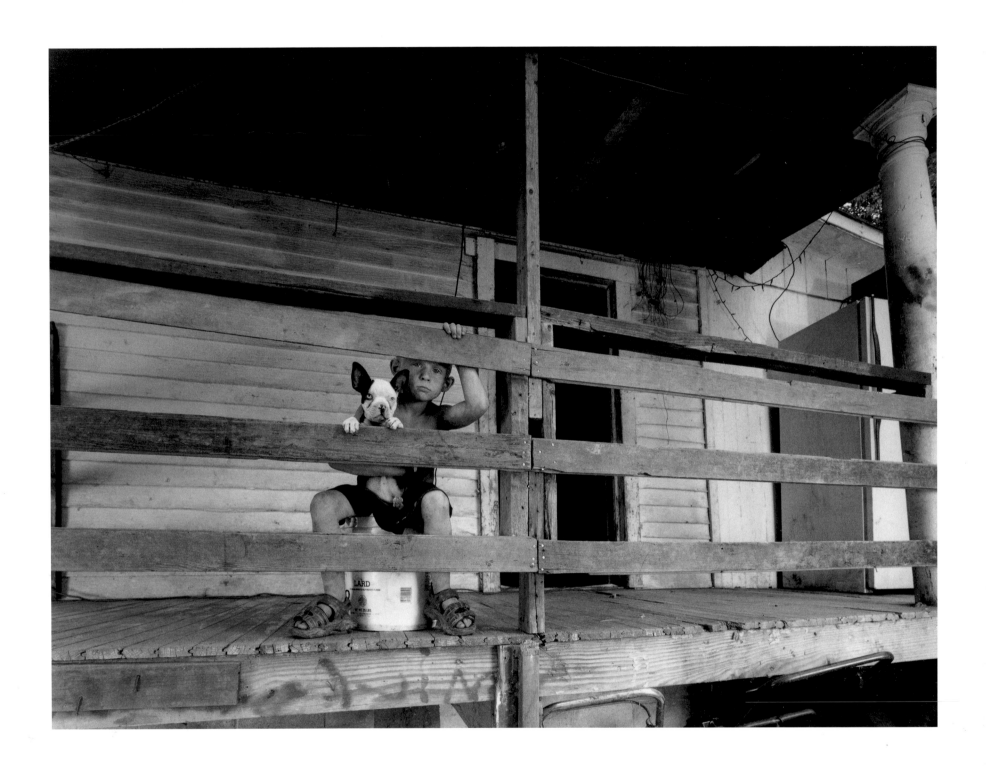

Tyler and Sheba 2001

The little girl's bite is examined; it is really only a scratch. She is more scared than hurt. Crying, she is taken inside the house.

As things are now somewhat quieter, I ask one of the kids to find an empty five-gallon plastic bucket so I can sit down for a while, rest, and drink some bottled water. While I am sitting, I ask the kids to name some of their pets, which they do: Rubberneck, Sheba, Cockroach, Blue Tick, Queenie, Little Bit, Jo-Jo, Bear, Co-Co. I have now figured out exactly how I want to make a photograph on the back porch and with whom. I ask Tyler, a little boy about five years old, to get Sheba, the Boston terrier, and stand on the porch. When he does so, it turns out that he is too short to look natural and be able to look over the hand rail. I have one of the kids take the plastic bucket up to the porch and ask Tyler to sit down on that. That works, but I must adjust the tripod to lower the camera. Kids start running around in the background, and I have to get someone from inside the house to keep them out of the photo area. We make our first Polaroid, which looks great. I need to adjust one light just a little. While I am doing that, the old dog comes running back to hide under the porch. The children all run, scream, and hide. Tyler is calm; he knows he is safe up on the porch. I direct him to lower his head ever so slightly and lift Sheba's body up just a little. "Both of you look right into the lens and don't move," I say. I whistle a little to keep Sheba looking at the camera and her ears perked. We settle into making several Polaroids and negative exposures. We are not interrupted for several minutes. It turns out to be a perfect shoot.

Earlier that summer, Sherman said to me, "You know I've been studying them Polaroids you left here last week of Tyler and Maranda and the rest of the family. I'd been thinking and lookin' at that picture of the light crossin' over the mountain with the kids in front—that is a really beautiful picture and the light is great. This is one of the best pictures you'd ever made there." Then, as we stood on the porch with the wind blowing and the summer rain starting up, Sherman looked out over the mountains and said, "You know I love living here on top of this mountain, because I can look out and see the mountains move and the trees move and it reminds me of that old black-and-white Japanese movie that's got Godzilla in it. It reminds me up here of that Godzilla landscape. I love this place."

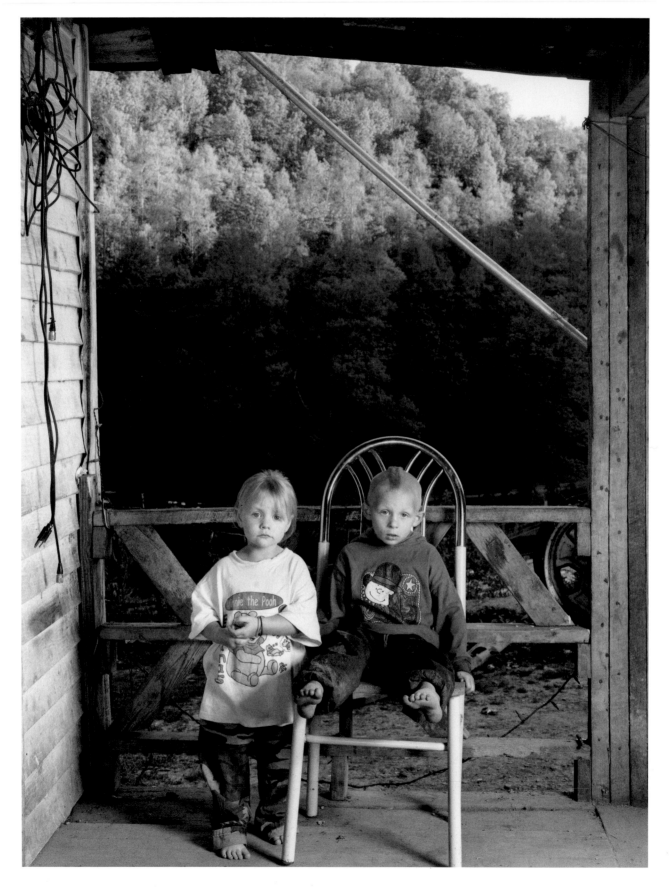

Tyler and Maranda 2001 *Christian 1999 >*

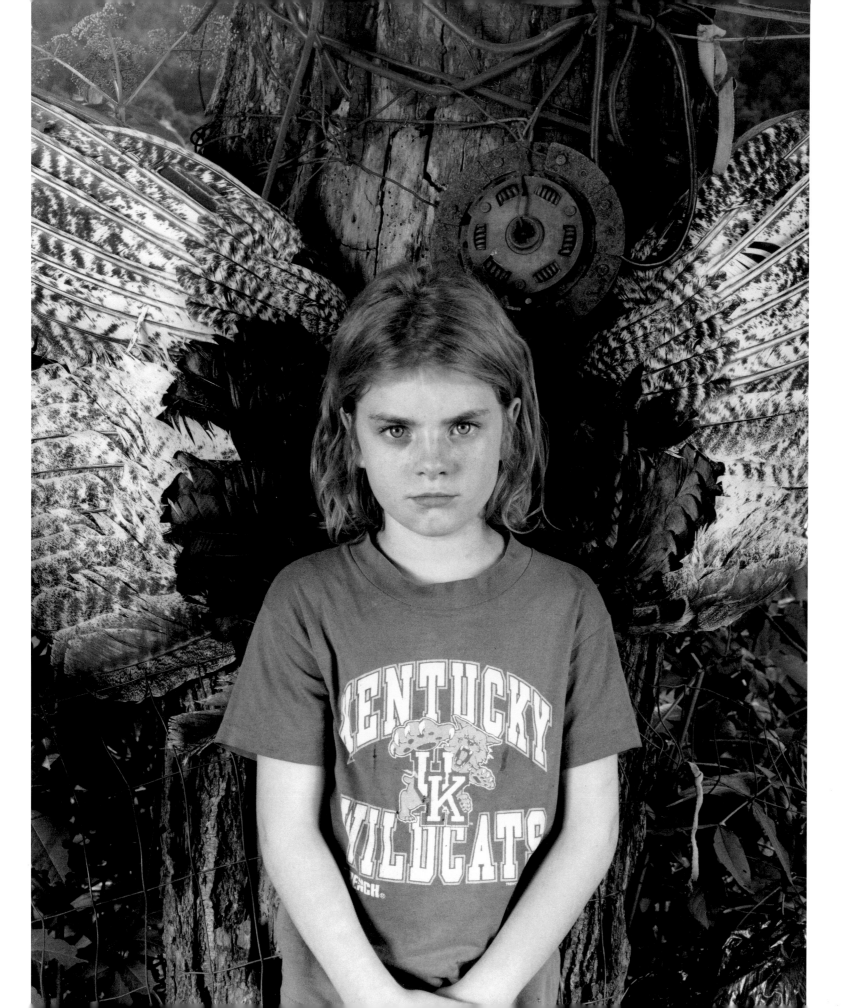

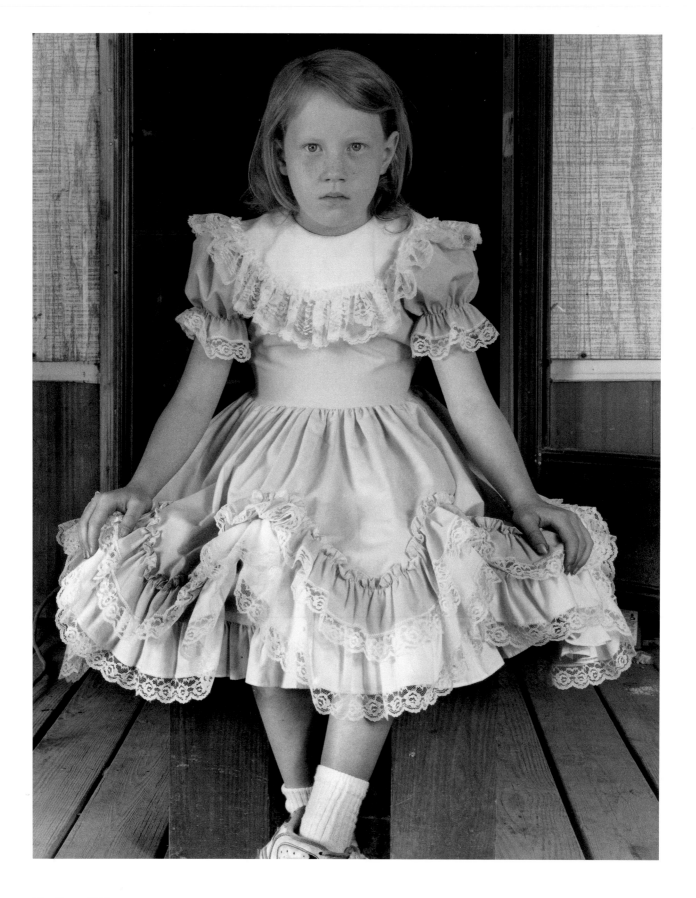

Sha-Sha 2000

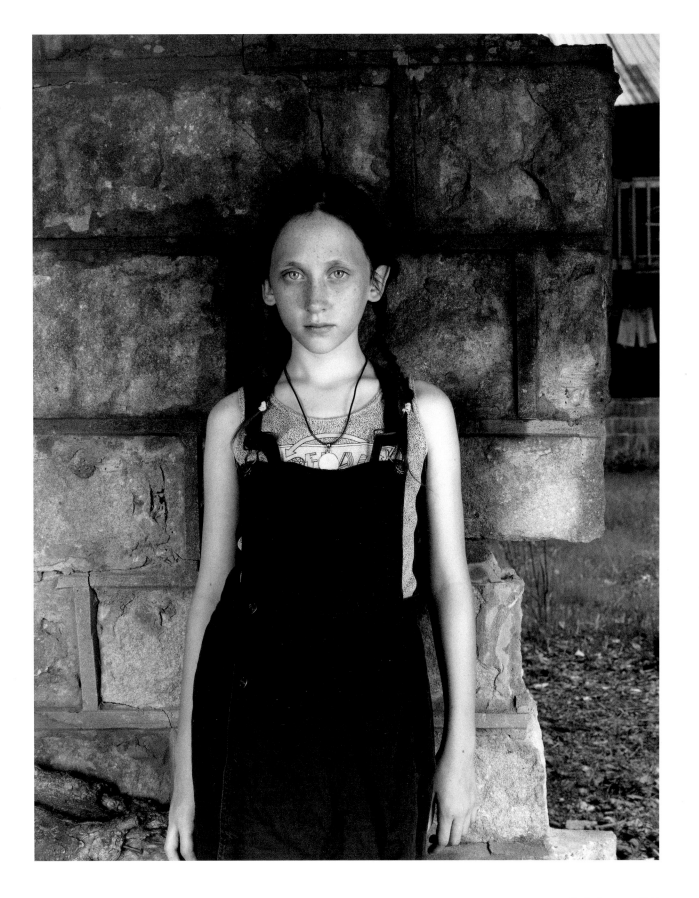

Kasie Dawn *2000* **13**

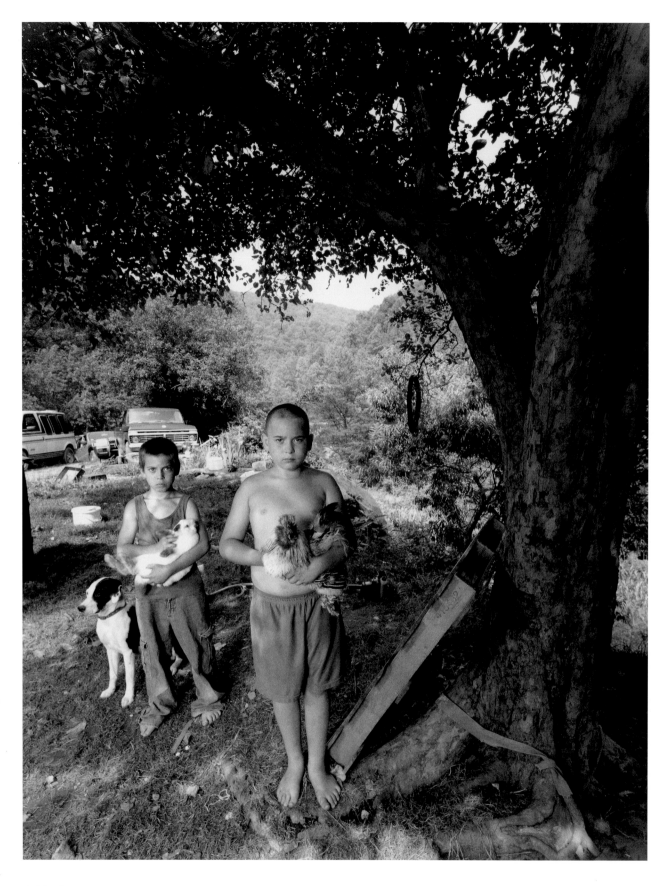

Caldwell Boys 2001

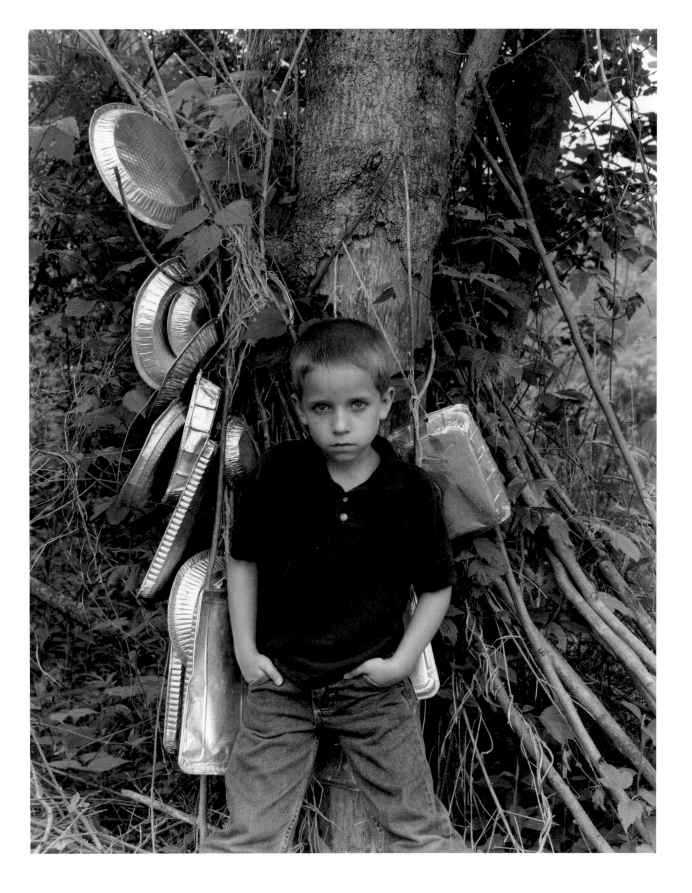

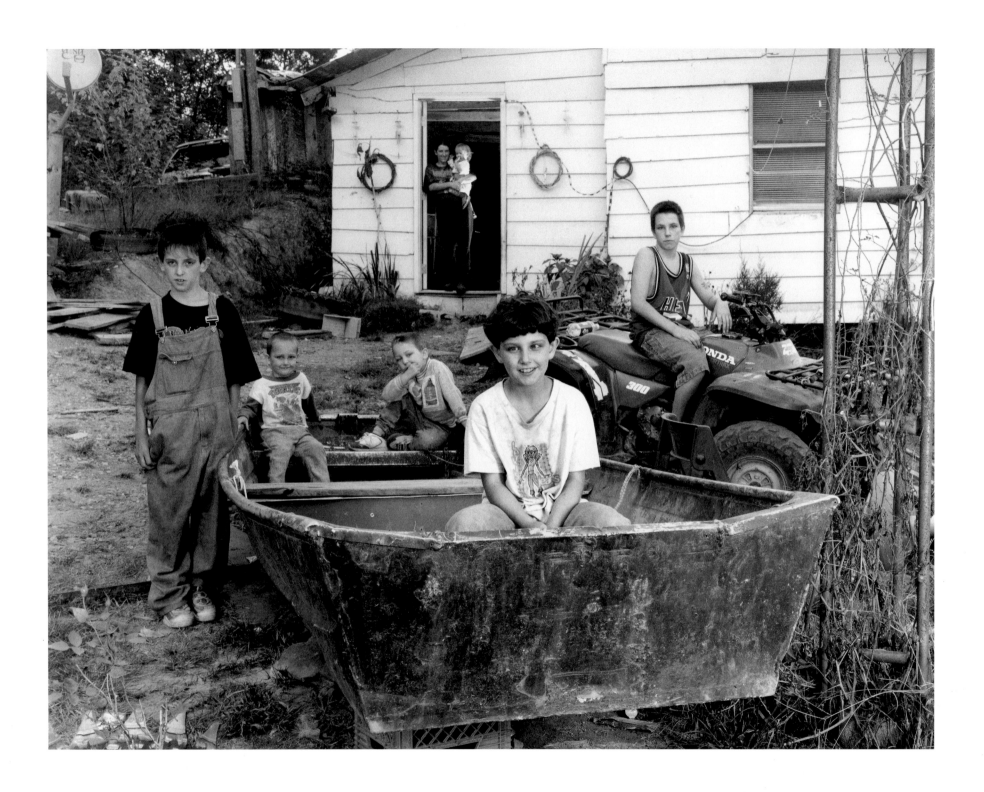

Freddie's Fishing Boat with Children 2000

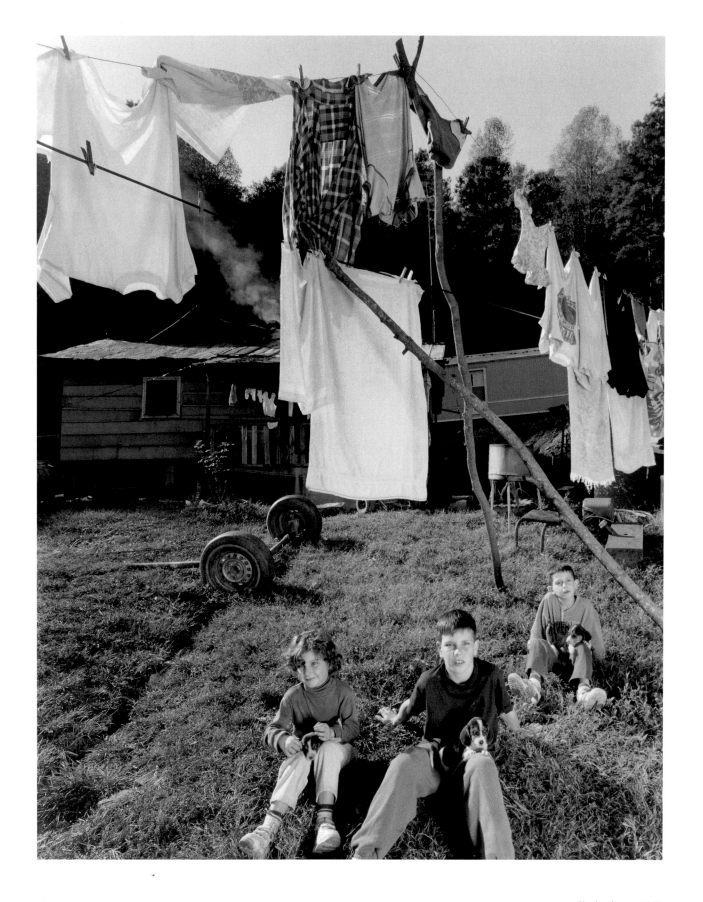

Clothesline 1997 **17**

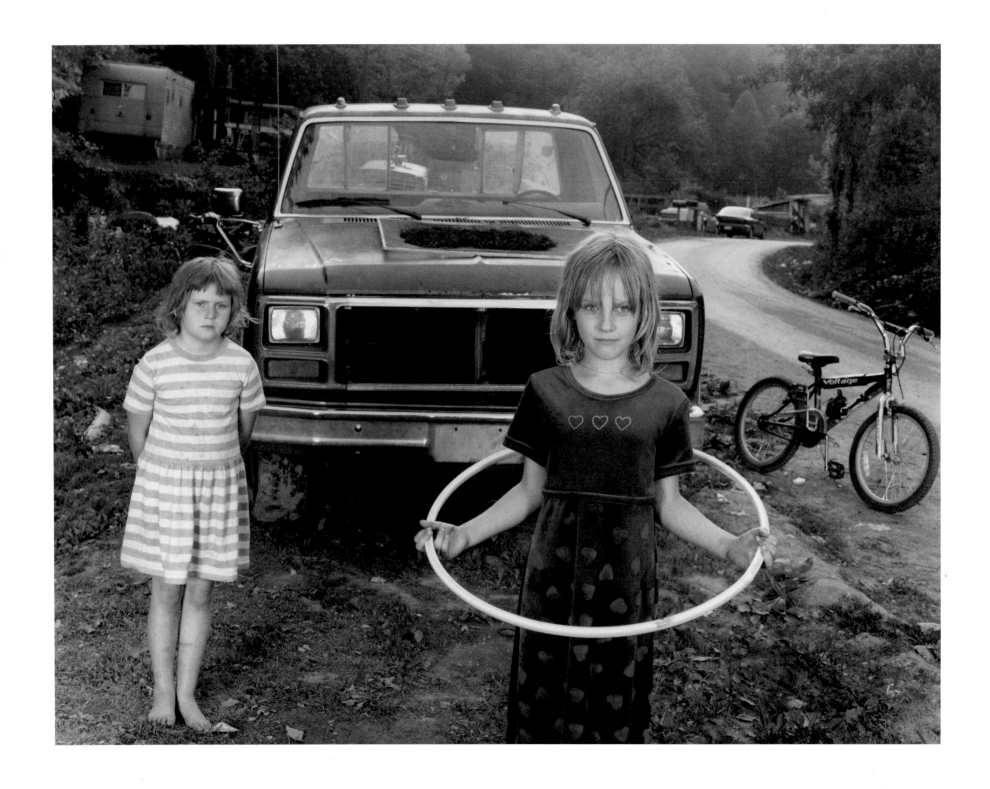

Nikki and Bobbie Jo 2001 *Bobbie Jo 2001 >*

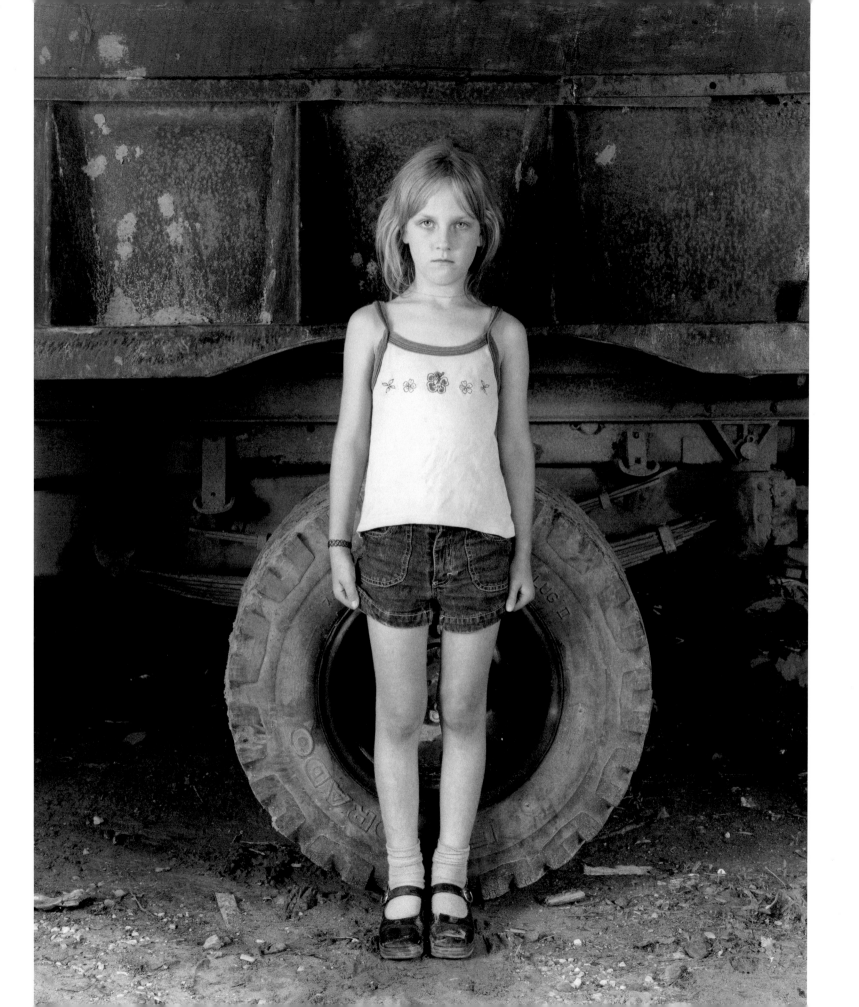

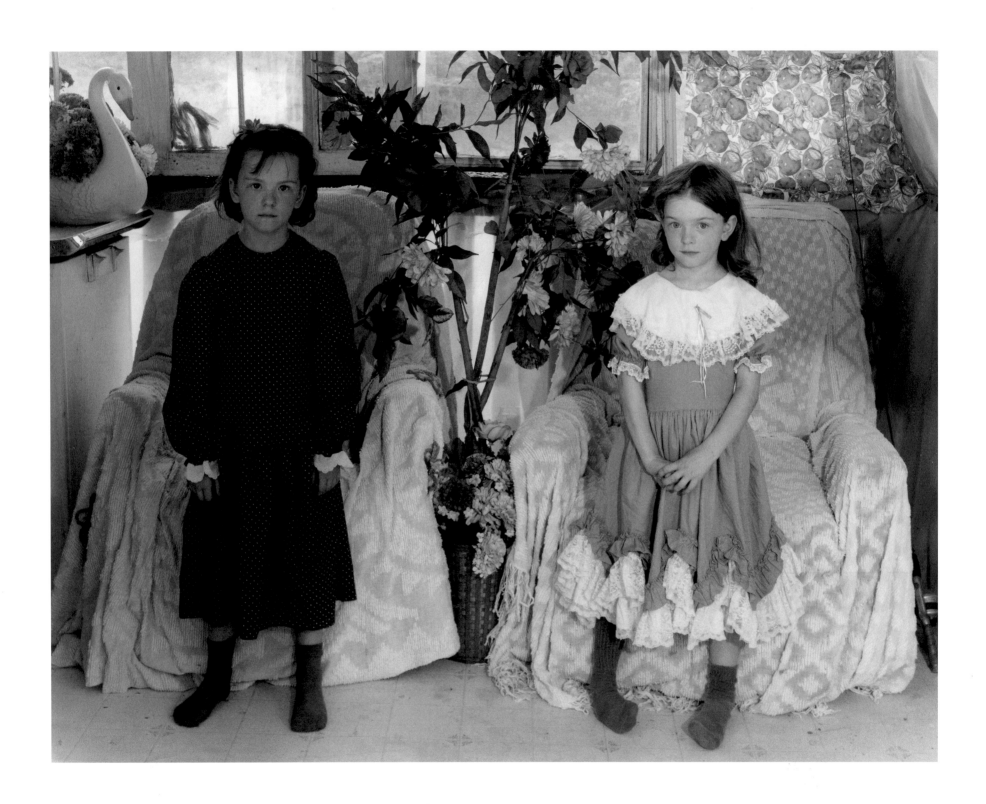

Shauna Faye and Stephanie Lynn 2001

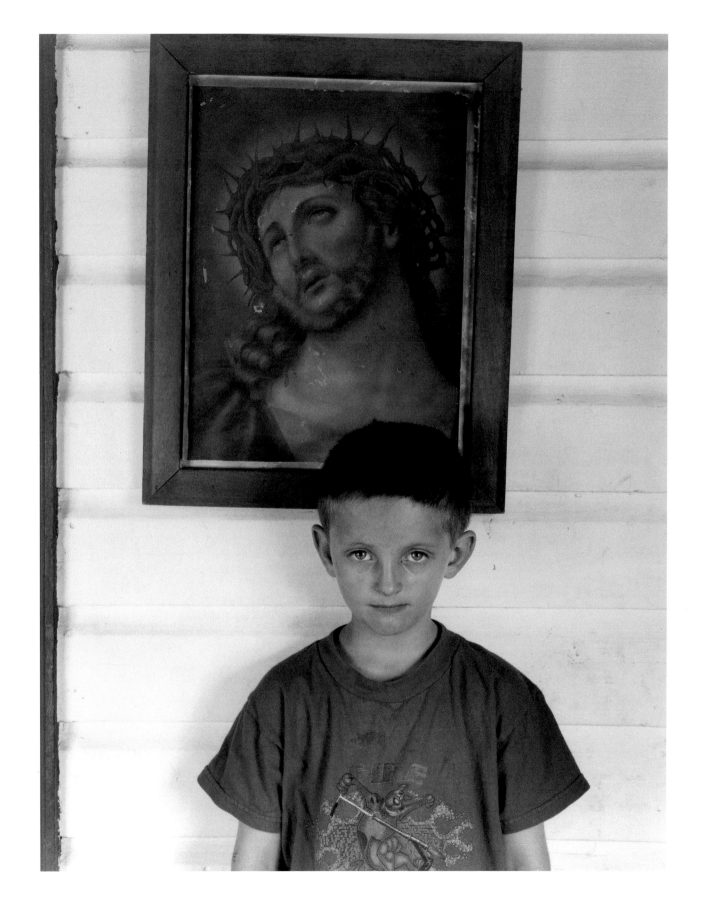

Eric 2001 **21**

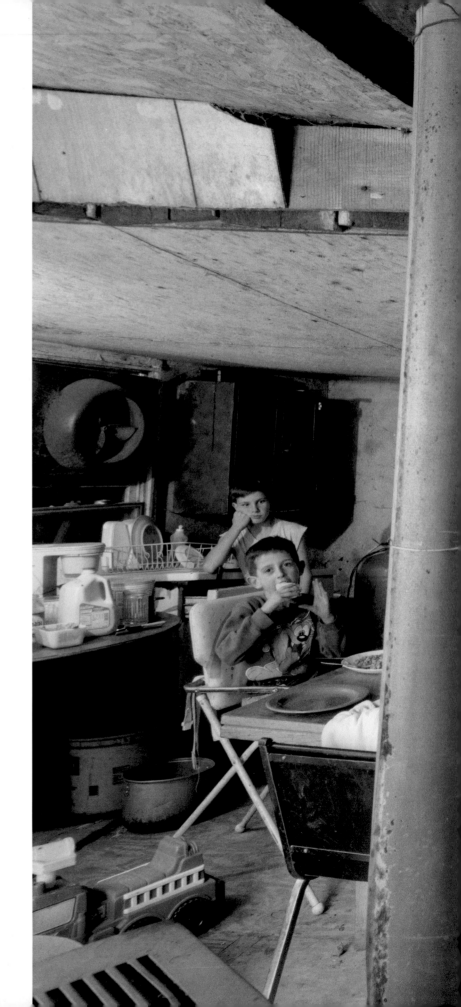

The Kitchen 1997

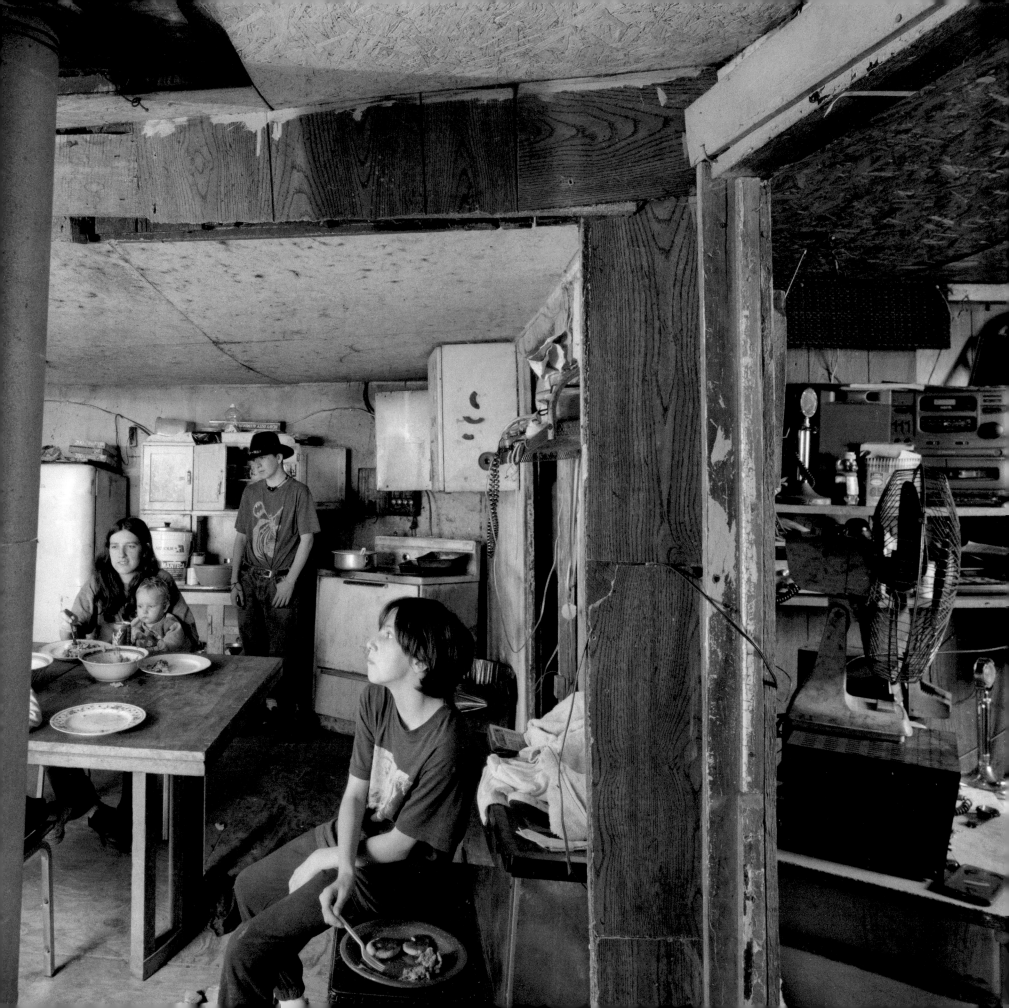

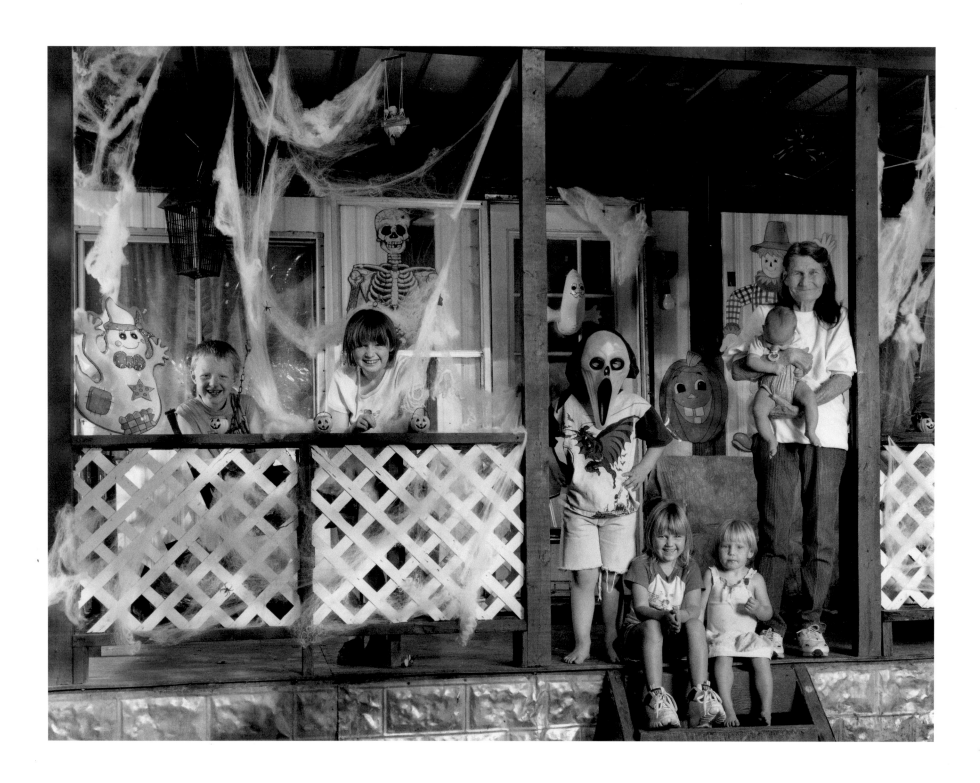

Smiths' Halloween Porch 1999

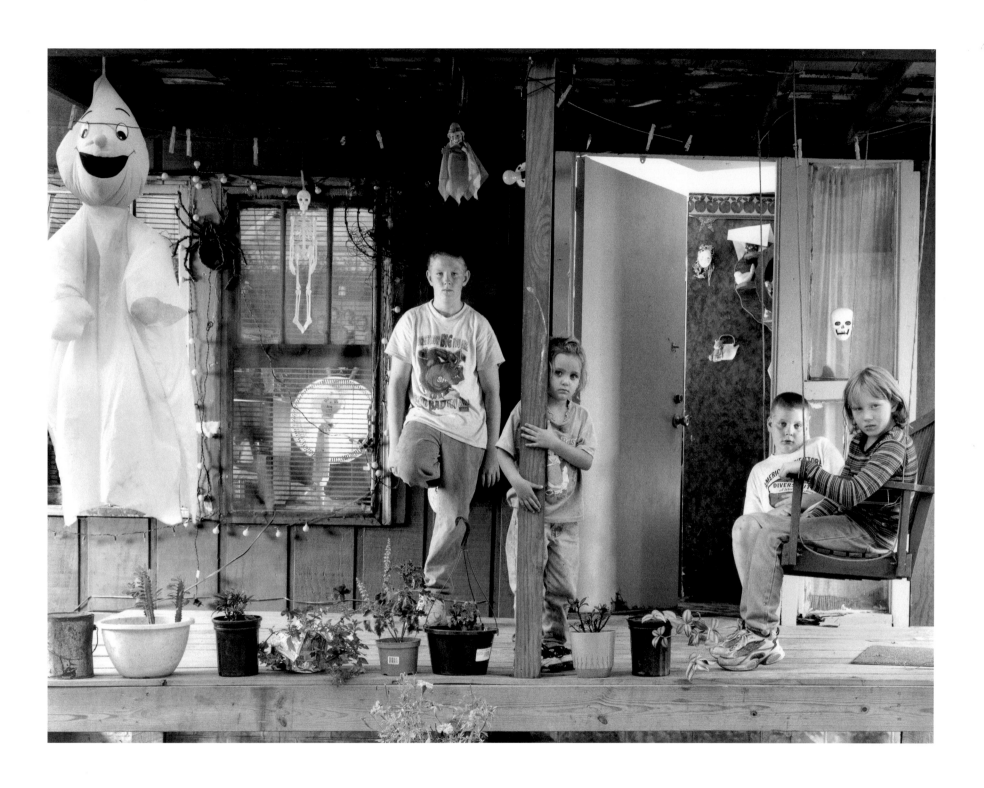

Halls' Halloween Porch 2000

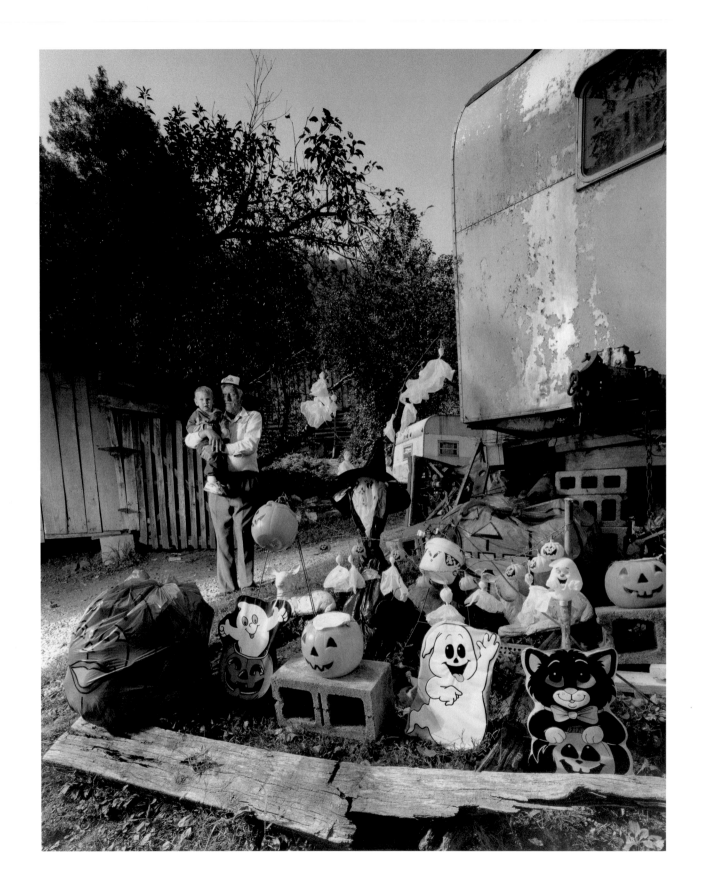

Halloween Yard 1997

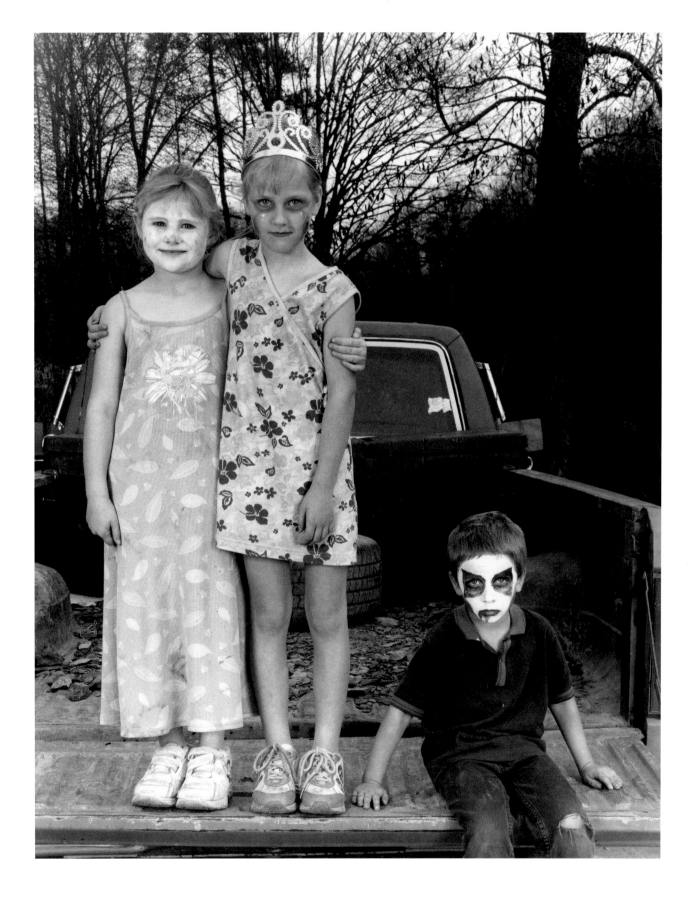

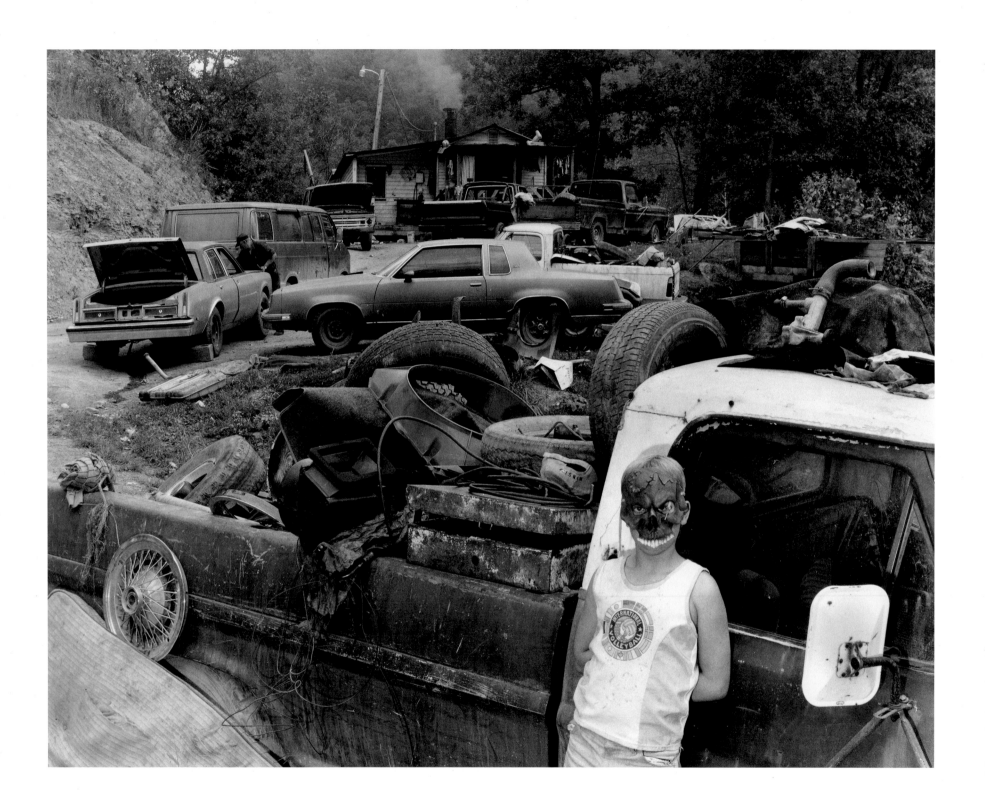

Sherman's Car Lot 1997

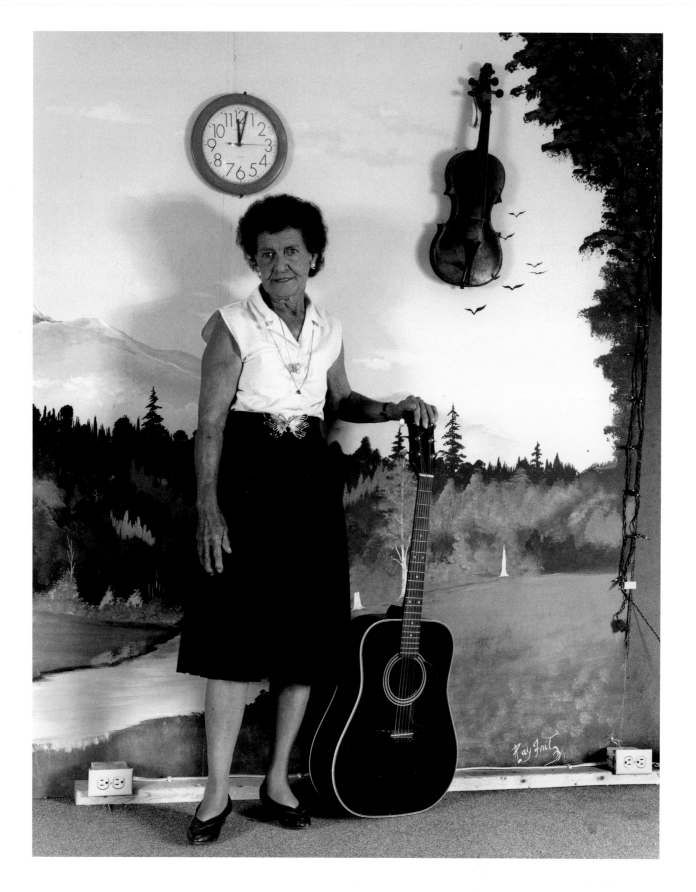

Della Mae 1999

In the eastern Kentucky Appalachian mountains we have a rich musical heritage. John Cohen writes in his introduction to *Mountain Music of Kentucky*, "Music is the celebration of the hard life in eastern Kentucky. The songs and ballads are a way of holding on to the old dignity. Music is not an escape; it presents a way to make it possible for life to go on." Much of this music is homemade, performed for the pleasure of the individual and the family; even the bands that play for social occasions are often composed of family members. The music is passed from generation to generation.

In my earliest memories of this musical heritage I am listening to and watching my maternal grandparents, Lee and Berthie Banks, sing to each other at home. My grandparents also introduced me to a kind of powerful and emotionally compelling music when they took me along to the services at the Old Regular Baptist Church. The music there expressed a deeply moving humility, spirituality, and soulfulness. During the summers from the time I was five through the year I was thirteen, I went with my grandparents to that church. What I remember most about the services is how men and women alike openly showed emotion. Big strong men cried under the spirit of the Lord, unreservedly wiping tears from their cheeks with white handkerchiefs. Seeing my grandpa and grandma cry in church scared me at first, but Grandpa talked to me privately and explained the joy in their hearts and the humility they felt. So I cried there, too, because they did. The mountain Baptist hymns still move me and always will.

In 1983 I attended my first Pentecostal Holiness church service with signs practiced. The music in that church was even more intense and emotional than in the Old Regular Baptist Church. Being there caused me to relive those childhood visits to church, and I began to be more aware of my roots. I could see the value of shedding an academic approach to my subject, of listening more closely to the people around and experiencing the culture as it really is, rich and full of life.

About that same time I met Roy Banks, a distant cousin. A self-taught musician from Leatherwood, Kentucky, he was leading a four-member country band called the Leatherwood Mountain Boys. Roy had learned to play music on a Gene Autry guitar that he had

mail-ordered from the American Seed Company for twelve dollars, a bonus for selling seed packets. "I started when I was sixteen years old," he says now. "I watched and listened to another local musician. I learned some chords from him and picked it up from there."

Roy has seen a lot of changes since the beginning of his music career. "When I started, we had to walk to any dance or place we was goin' to play at. We played at square dances, cake walks, box suppers and even shootin' matches; anywhere there was goin' to be a crowd. A lot of times you just had to go where you could catch a ride, and hope they wasn't drinkin'. Today it's different. I have a Martin guitar, I play at family reunions, wedding receptions, political rallies, music barns, and even music festivals. Now, I have a car and give private music lessons in people's homes and get paid by the hour. Also, I sell cassette tapes of my recorded music and travel all over the mountains." Like many mountain musicians, Roy has passed his love of music on. He says he started his son Jack playing the keyboard when the boy was four years old. Now in his twenties, Jack plays banjo, guitar, mandolin, keyboard, and harmonica.

Thanks to Roy, who took a keen interest in my photography as soon as we met, I have been able to meet new families. Often accompanying me on photo sessions, he has been helpful in putting people at ease, sometimes playing music for them as I set up my equipment and make the photographs. Roy reminds me every once in awhile that "you have to get in real good with the people. Some of 'em are skittish, especially about pictures." Many of the photographs I have made over the years would never have happened without Roy's help.

A good example of a photograph made with Roy's help is *Crafton Barger and Sons, 1999*. It was a rainy day when Roy and I pulled up to the Barger home in Saul, Kentucky, to ask directions. Doug, one of Crafton's sons, came out in the rain to offer us help. He recognized Roy immediately. I heard him say to Roy, "I don't mind gettin' wet—it's what we are supposed to do, help our neighbors." The family invited us in for a visit and agreed to be photographed. With the help of Doug and Coburn, another of Crafton's sons, I set up and made the photograph on the front porch after dark.

Crafton, who's in his sixties, told me he started learning to play the banjo when he was twelve years old. His daddy had two banjos, and, when he would play, the boy would get the other one and pick along. "John Henry" and "Pretty Polly" were the first two songs he learned to play. He said he liked playing that good old homemade music and just kept it up.

When I returned to the Barger home the next year, I gave the family some photographs I'd made with Roy on the visit before. Crafton then showed me around his place. He told me that he and his wife had built their home by hand when they were first married. "We used a crosscut saw to cut the wood," he said. "We've lived here ever since."

He had quite a garden across the road from where they lived. Crossing the two-lane blacktop, I could tell I was entering another world. I saw an old wooden well box with a chain and bucket. Crafton told me it was a thirty-six-foot-deep well, hand dug, and that it still had good water. The pawpaw trees, bearing fruit, gave off a smell I'd not known since childhood. More important was what I thought I'd seen from the porch of his home. It was foundation stone—creek-bed stone pulled from the bottom of the river many years ago by early settlers, who had used oxen to remove the stones and sledgehammers to break them apart. I knew the color and texture of this kind of stone, its shape and size. I'd grown up playing on similar ones at my grandpa's farm forty-five years ago, and they were the same in Saul. These stones were our history, and Crafton had kept them visible.

We went for a walk in his garden, where he had the usual staples of corn, potatoes, and beans, plus much more. Crafton loved growing and pollinating fruit trees. He had every kind of apple tree, including Red Delicious, Yellow Delicious, Red Jonathan, Yates, Winesap, and June apples, as well as other fruit trees. He also had a patch of ginseng growing, hidden under the trees. It was protected on one side by six-foot-high purple dog-tick plants, also called castor beans, grown to keep the moles out of his garden. He talked about the time it takes to pollinate fruit trees—sometimes up to five years before a tree begins to bear. There was something about that he liked, and we smiled at each other.

We walked back to the highway, then stopped and talked before crossing over to his home. Crafton looked at the road, telling me how peaceful it was when he and his wife built the house. In the fifties, the U.S. Army Corps of Engineers created the reservoir that now forms the backwaters near his home. Every summer now, at all hours of the day and night, the road past Crafton's house is clogged with towed fishing boats, camper rigs, and drunk drivers. Looking up at the mountains, he told me with a worried tone in his voice that a strip-mining company was now mining near his property.

A couple of years ago at the end of a photography visit at the Sherman Jacobs home in Neon, Kentucky, I asked Sherman to describe some of his music-playing buddies. He told me about his friend David Helton, who lived in Jenkins. Sherman said that David had a very pretty daughter who wrote her own songs and that I might want to get a picture of her. I asked Sherman to introduce me to this family, and he agreed.

During my first visit with the Helton family, I photographed Rose Marie, then age thirteen, in the yard, holding her guitar and leaning against her daddy's Triumph motorcycle. The next year, when I returned with photographs to give to Rose Marie and her family, I told them that I thought the pictures were not as good as I had hoped they would be and asked if I could make some more. The Heltons had now moved to Quillen Fork and were

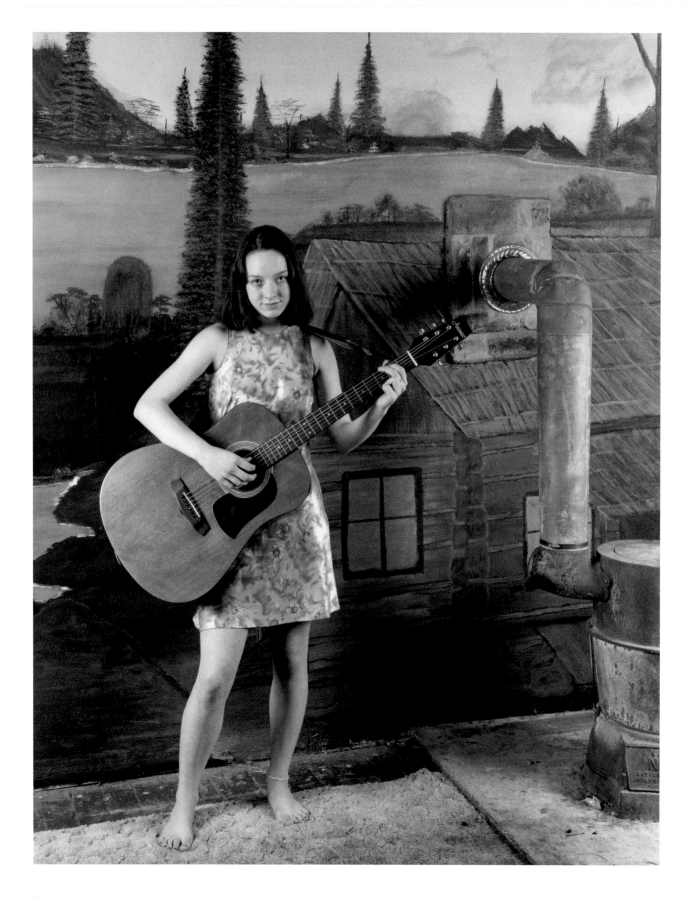

Rose Marie 1999

living in the last house in the hollow. They said they felt happier and freer there with no one too close by.

Rose Marie had been playing music since she was five years old. As many mountain musicians do with their children, her father had been teaching her all he knew about music. She accompanied her dad playing and singing on weekends at church functions throughout eastern Kentucky and western Virginia, having learned to play the guitar, the banjo, and the dulcimer. She wrote her own songs and performed them with her dad. One song she wrote reflects her parents' teaching. "I remember what Mama said when I was a little girl, be real good and listen to what is said. In school, be real good, do your work, and do what you're told." Her parents are extremely proud of her.

Rose Marie wants to become a country music singer when she finishes school. This is not just a schoolgirl dream. Her father has taken her to many weekend courses in Nashville. She learned how to apply makeup and style her hair at the Wella Hair Styling Company, and she has attended the Barbizon Modeling School for instruction in posing, dressing, and working before TV cameras. She and her father have traveled throughout the mountain area to meet and work with musicians who can coach Rose Marie with her music.

Rose Marie loved having her photograph made. When we made *Rose Marie, 1999*, I encouraged her to pick her own dress and do her hair the way she liked; wisely, she chose not to wear too much makeup. Her dad had just that winter finished painting the mural that covered their living room wall. (In the summers he sells his paintings and painted rocks at roadside stops and yard sales.) When I saw this wall in their home, I knew it was the background for the picture of Rose Marie that I wanted to make. I selected the guitar from the four the family owned. Her parents watched attentively as we made Polaroids and studied them together. I wanted her to see herself on film and to be comfortable with what she saw. Our session lasted for over two hours before we made the final photographs. Her father said, "There's sure more to this than a single picture shows."

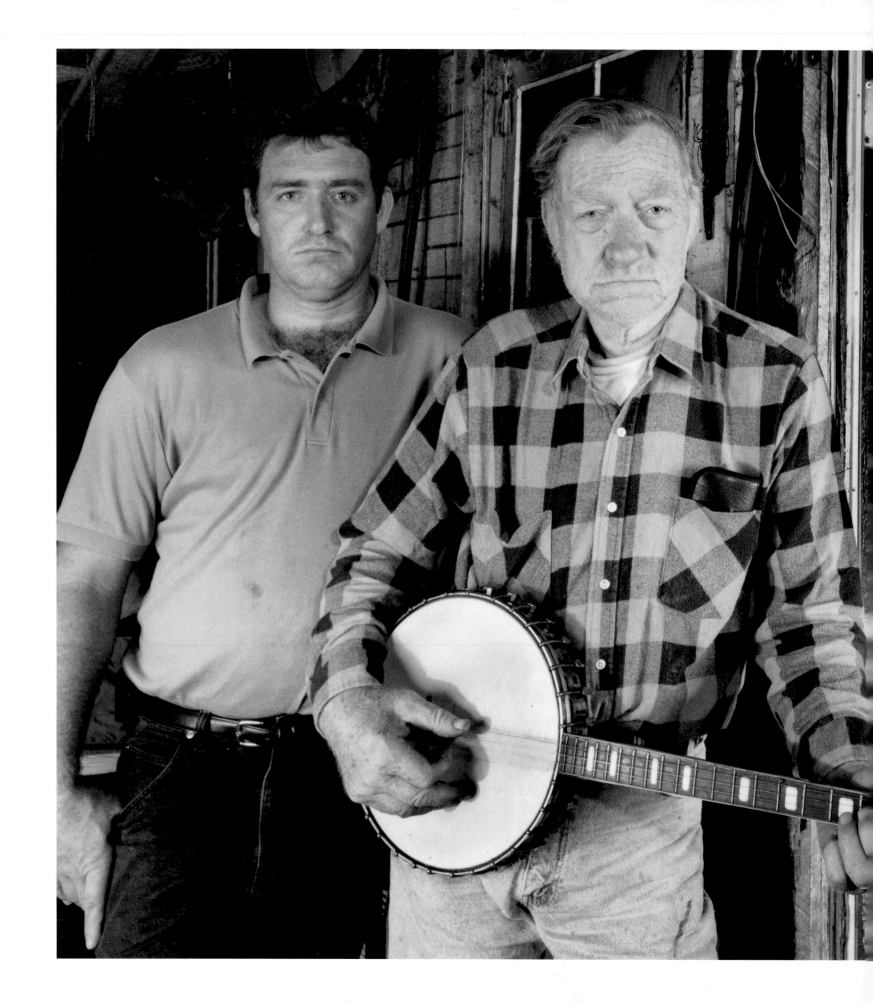

Crafton Barger and Sons *1999* **37**

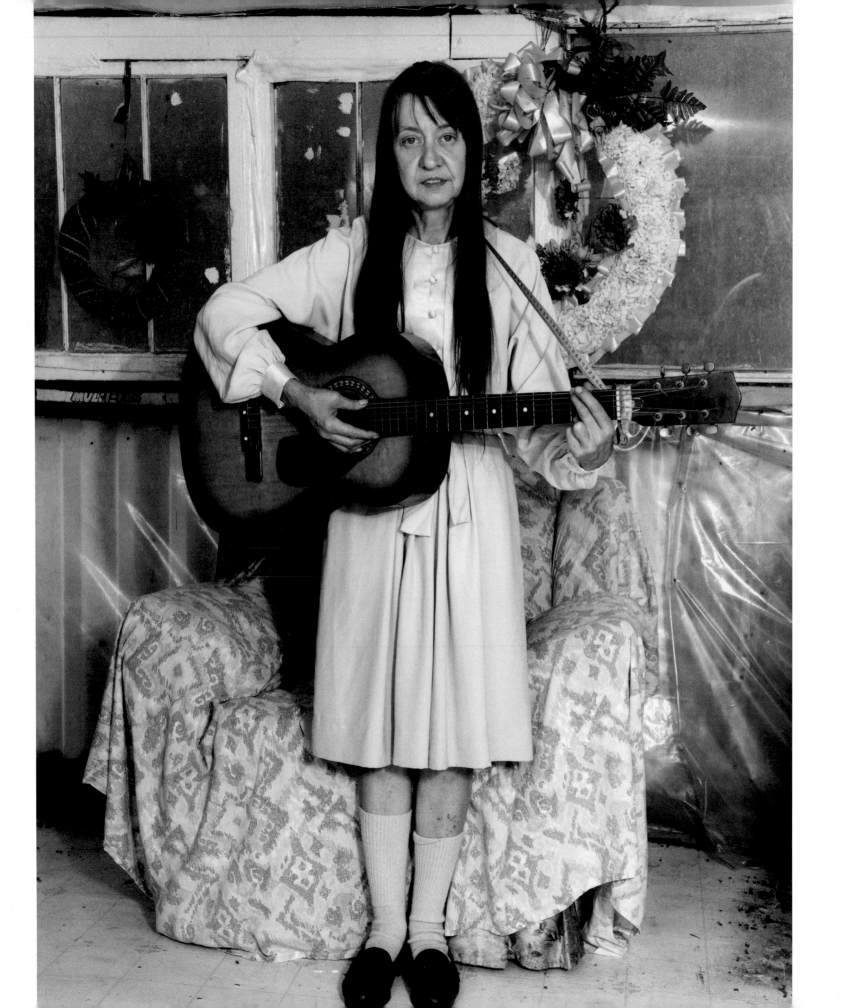

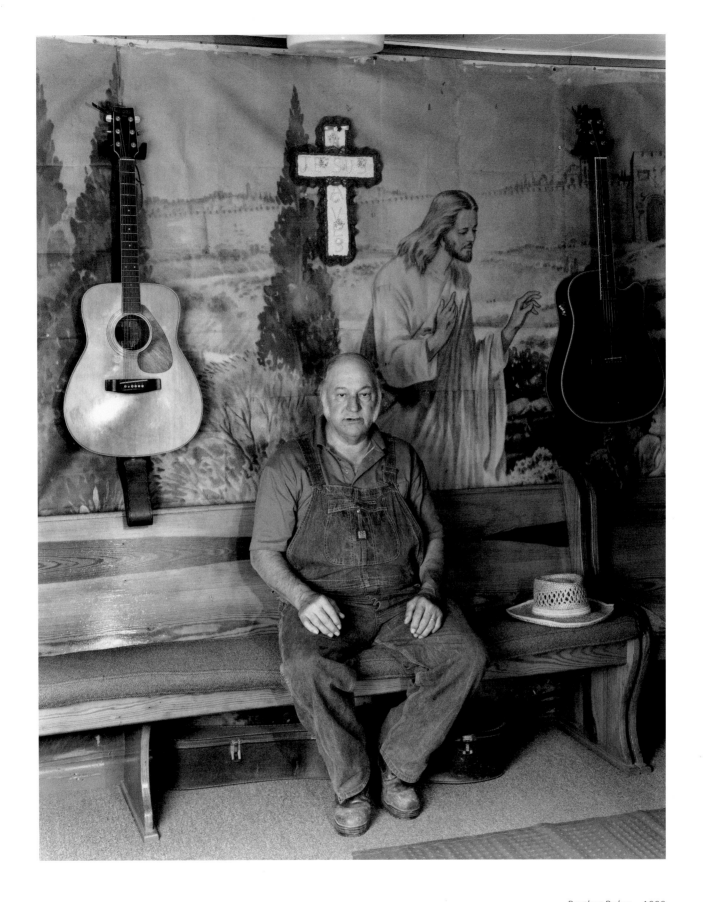

Jack with Banjo 1988

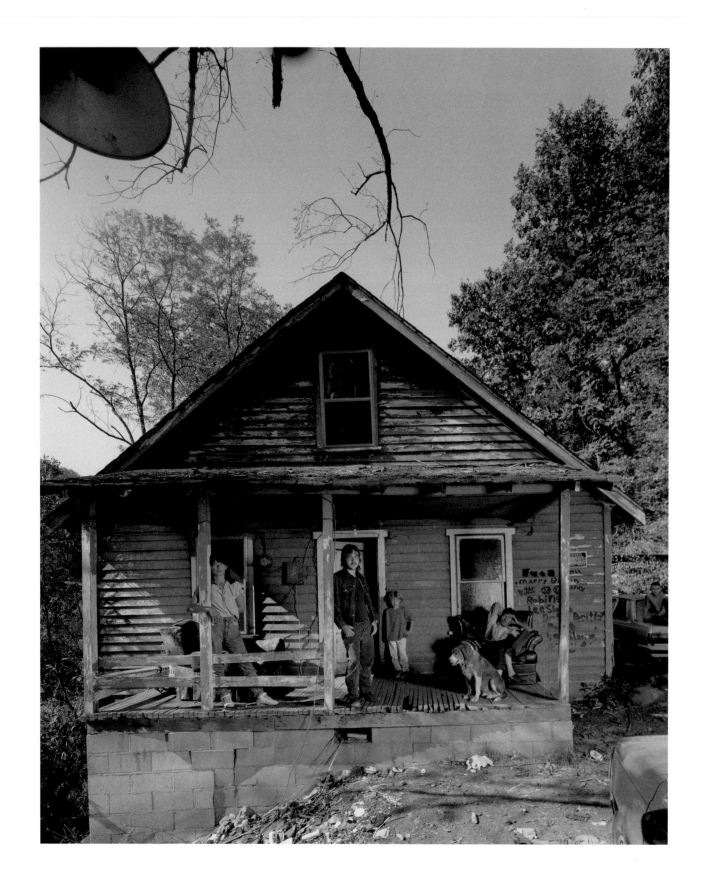

The Old Home Place 1997

Photographs of three members of the Slone family—Leddie, Lonnie, and Burton—were featured in my first book, *Appalachian Portraits*, published in 1993. Lonnie has since died of a heart attack; Burton was hit by a car, institutionalized, and died in a nursing home in Pikeville, Kentucky. Leddie, now in her late seventies, lives alone in a trailer on Slone Mountain. She has many children, grandchildren, and great-grandchildren. In *Smiths' Halloween Porch, 1999*, she can be seen proudly holding one of her great-grandchildren, and she also appears in *Hylo's Place, 2000*. When I began photographing the Slone family in the 1980s, they all lived in the house shown in *The Old Home Place, 1997*. The house is now abandoned; it is used by Dan, the youngest brother in the family, as a drinking place for his family and friends. Dan and his wife, Flossie, married for over forty years, are the parents of six children. Dan and his daughter Wanda Lee have been my friends and the subjects of my photos for almost twenty years.

On a beautiful day in October of 1997, I go to visit the Slones, stopping at Dan's on the way up the mountain. Flossie tells me that he is up at the old home place, drinking and cutting up. Pulling into the drive, which is overgrown with weeds and littered with broken glass, I make my way slowly, smashing aluminum beer cans and other objects that make crinkling and popping sounds. Dan greets me from the porch, calling, "Come on in, we ain't seen you in quite a while." Everyone is sitting around drinking Milwaukee's Best. A couple of dogs run up to me, barking and jumping up on my legs. Wanda Lee yells at them to get down. There is no place to sit except on the edge of the porch; Dan is sitting in the only chair. We shake hands.

After visiting and catching up on the latest news, I set up my camera, and we take photographs of everyone on the porch. For fun Dan wears a cowboy hat, and he is holding the ever-present beer. He asks me to be in a picture with him. We get Wanda Lee to take the photo. Dan laughs and says, "Make sure you don't bust the camera with this one." I make several Polaroids to give to everyone. I meet Wanda Lee's new boyfriend, Roland Johnson.

Packing up my equipment later on, I look around, reflecting on the beauty of the day

and on how open everyone is. I think about my history with this family, some present and some now gone. I recall photographing Burton over ten years ago in this yard, right where my car is parked. I remember what he meant to me, what he gave me, what a skittish, wonderful, sensitive soul he was. I turn around and look at the house, with everyone on the porch, and realize that I have not gotten a good photograph. Then I see what I had not seen previously and ask if I could take just one more picture. It would be a portrait of the house, something I had not ever done before.

When finishing this photograph, I coat and give some 4 x 5 Polaroids to everyone. I have not photographed Roland Johnson before and do not expect to see him again. I ask him if he will sign a model release for me so that I can use this picture in one of my books. I always hate this part of my work, but Roland surprises me. He slaps his knee and says, "I was hopin' you'd get a picture of me for one of your books. I know all about you. I studied your pictures in the pen. You're like Danny Lyons, Bruce Davidson, and all them guys. I studied photography when I was in the La Grange State Penitentiary, and I know a lot about your pictures." He continues, "What you are doin' is expressin' yourself and showin' how you feel about us. Not everybody can do that! You'd do what you're doin' even if it cost you money, because you're interested in doin' what you love. You can see that in your pictures. Yeah, let me sign one of them model releases, I'd love to be in one of your books." I am somewhat taken back by this response and would later try to reproduce it as accurately as possible. I was not to meet Roland again; Wanda Lee would later tell me that he was back in prison for breaking parole.

The next year when I return, I give these photos to Wanda Lee. She has a new boyfriend named Tim. Wanda Lee is an attractive and intelligent woman who has gotten a GED high school equivalency diploma and has been taking courses part-time at the local community college. We have often discussed these courses. We both like to talk about Appalachian studies and the southern writers we have read. I have always encouraged her to try and finish the two-year college program.

A single parent, Wanda Lee has four children. When I ask her why she has never married, she replies, "A lot of my relationships just fell. I expected too much from a man. The men would go out on me, after twice I'd quit 'em. I'd feel like they didn't love me and that was it. I was afraid—things get in the way. The men didn't care enough about me. I'd never seen them care enough. I know how I felt, but I never seen them love me enough. Some people are afraid to commit to a marriage. You shouldn't be afraid of that. If you really truly love them, go for it. Some you hear say, if they marry, they can't be themselves, 'cause they're afraid of being controlled. Let 'em be themselves, accept a person for how they are. A woman wants a man to share time with them. Time is important to a woman. I enjoy my

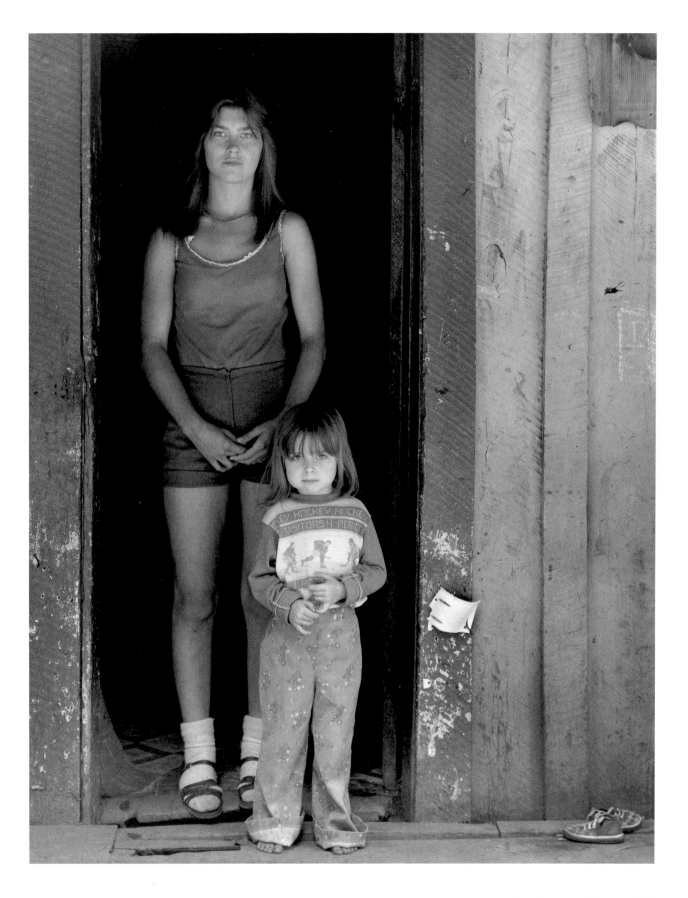

Wanda Lee and Stacey 1985

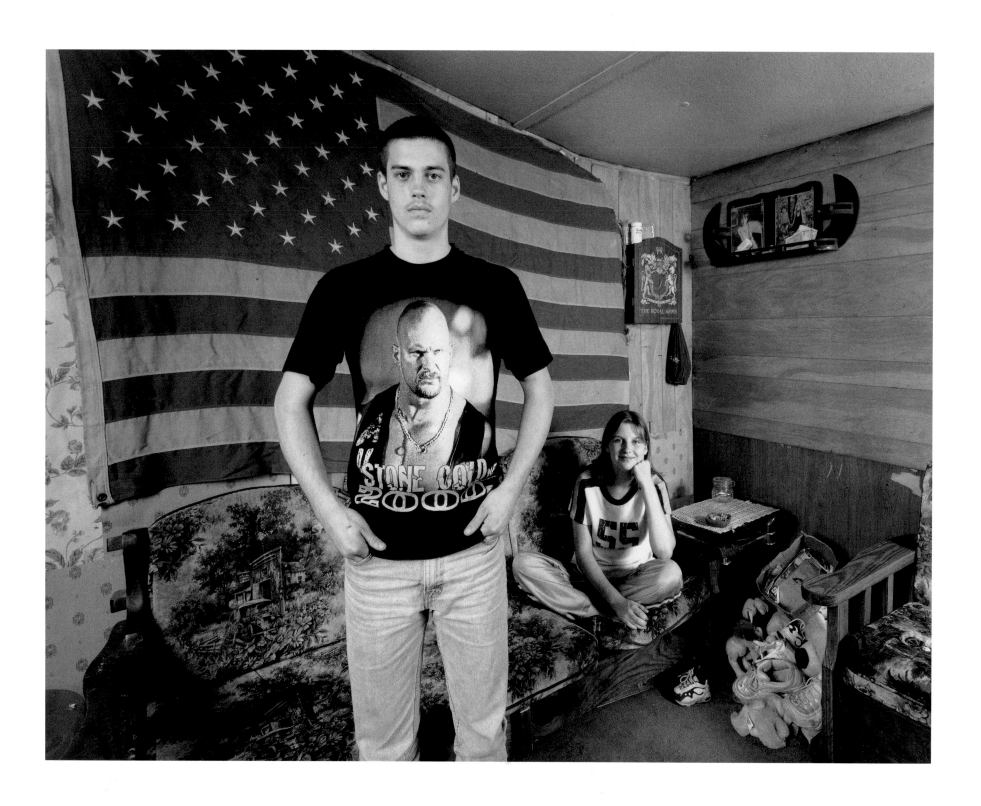

Pete and Stacey 1999

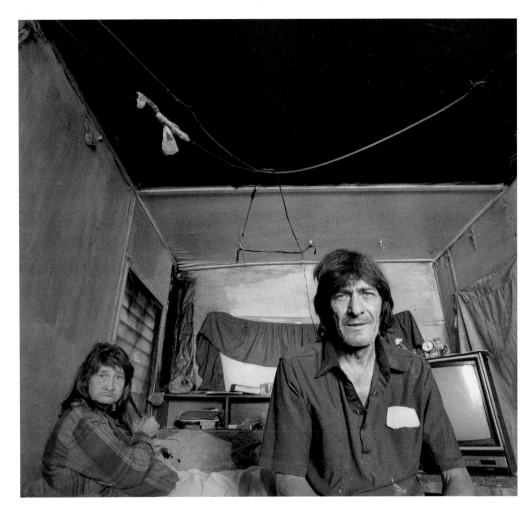

Dan and Flossie 2001

freedom. If a person would let you be yourself, then marry, you ain't got no worries. A lot of people won't marry; they're afraid of failure. We are all different and our love is different."

While we are talking, Brian and Travis, Wanda Lee's two sons, come running from the school bus and want something to eat. They ask for pizza or chicken strips or bologna sandwiches—whatever she can fix quickly.

Speaking of her current relationship, Wanda Lee tells me, "My man, he gives me a flower, a rose often. He might not have no money, he'll pick me a flower, and that makes me feel loved. If he's got me on his mind, he'll bring me a flower. I had men buy me things, but I ain't had no man just bring me a flower. Money don't make love, you see love in their ways."

Stacey, Wanda Lee's older daughter, has just lost her man, Pete. He was killed in a car crash right in front of Leddie's trailer. Wanda Lee says, "It will take her a while to deal with it. She's got to accept he's never coming back. Before, they'd break up, but she knowed he'd come back. Now, she's got to accept his death. It's hard on her right now."

After Wanda Lee and I have visited for a while, we walk over to Dan's house, just a short

distance away. Wanda Lee keeps her computer at Dan's so her kids can't get to it so easily. She turns it on and starts working, while Dan and I talk. Dan tells me that, since this is election time, cases of beer are being given to him and his family. "They brought twenty cases of blue-labeled Polar Bear beer here in the back of a truck one time, and then another ten cases later on. We call it election beer. It ain't no 'count—it has meat in it, from the dead people." He laughs heartily. "When you get ready to go, you take a case of it with you. It's killing me. I got to get rid of some of it." Dan asks me to follow him out to his pickup truck, where he shows me cases of beer in the back under a canvas tarp. When I ask him about his truck, he says, "This is a 1979 Ford F-150 one-ton pickup. Only got a little over 260,000 miles on it, and it's in great shape. I wouldn't have one made after '86; they got computer parts in them, you can't work on 'em. This old one here is easy to keep runnin'."

After looking inside Dan's pickup and seeing the tapestry of stallions he has put on the inside of the roof, I ask him if it would be all right to photograph him sitting in the truck. He likes the idea and asks me if I would like to drink some beer. I tell him that I might mess up the pictures if I am drinking. He laughs, saying, "You won't mess up." He places a Ralph Stanley tape in the truck's tape player and cranks it up. I start unloading my equipment.

I set my view camera in the open doorway of the truck, opposite Dan. One of Wanda Lee's boys runs an electric cord for me from Dan's house. As it gets darker, more and more men start showing up at Dan's truck to get a beer, hang out, and, as it turns out, watch me photograph. I set two light stands up facing into the interior of the truck, one through the windshield. I pull a couple of Polaroids; it's dark now and I need more lights. I set up another pack in the bed of the truck to illuminate the rear window. I need another light to make the inside of the roof show up better. Placement of this light takes quite a while. A lot of folks are milling around, tripping over my cords in the dark and knocking things about. Dan is drinking and playing his country music tapes.

After about three hours of setting the lights, carrying on conversations, and photographing some of Dan's relatives with him as they stop by, I am finally ready to shoot some film. Then, in the most serious voice I've ever heard him use, Dan says to me, "Shelby, you know, I'm driving straight to hell. You know, Shelby, I'm driving right straight to hell." He looks through the windshield and then back at me and starts laughing. I make the picture. It is late by the time I get all my equipment packed and am ready to leave.

When saying good-bye, I ask Dan how many days he has been drinking. He says, "Three days that I remember." Dan tries to insist that I take a case of Polar Bear beer with me, but I refuse. He says, "How about taking a case of this beer to them boys on Leatherwood that are in your book, the Napier boys? I'd like to know what they think of this beer." He laughs. "I bet they can drink it." He loads a case in the back of my vehicle. Later, word will come back to the Slones that the Napiers couldn't drink the beer either.

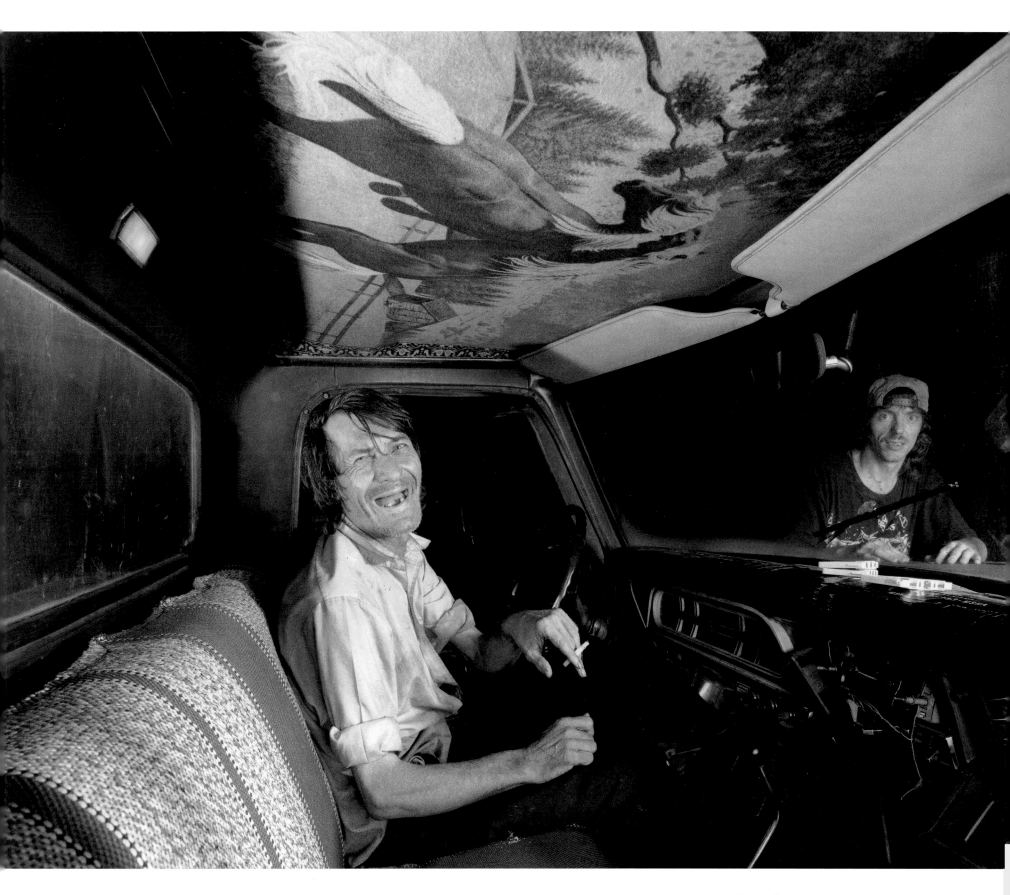

Driving Straight to Hell 1998 **49**

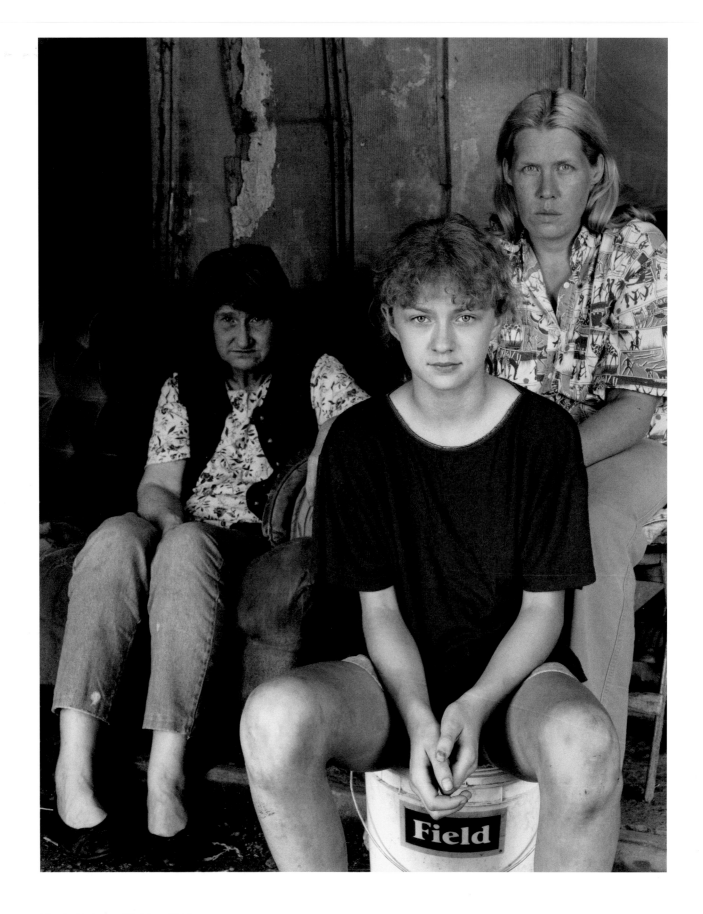

Flossie, Kathy, and Robin 2002

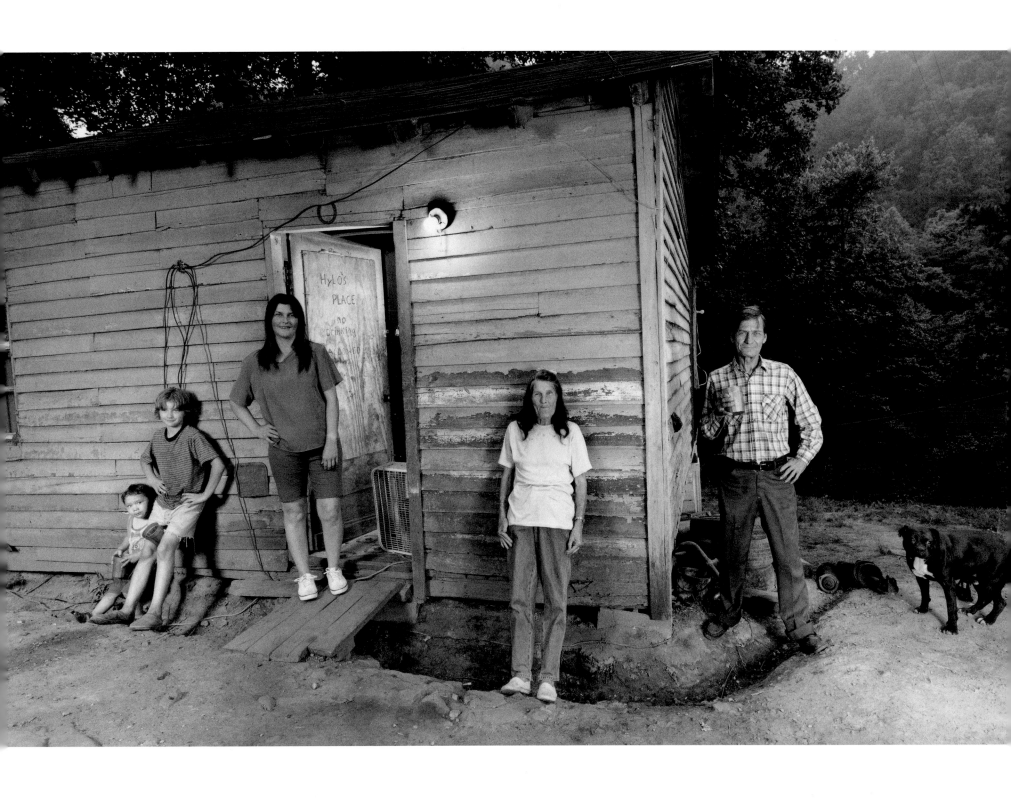

Hylo's Place 2000 *(Pages 52–53: The Halls' Porch, 1998)* **51**

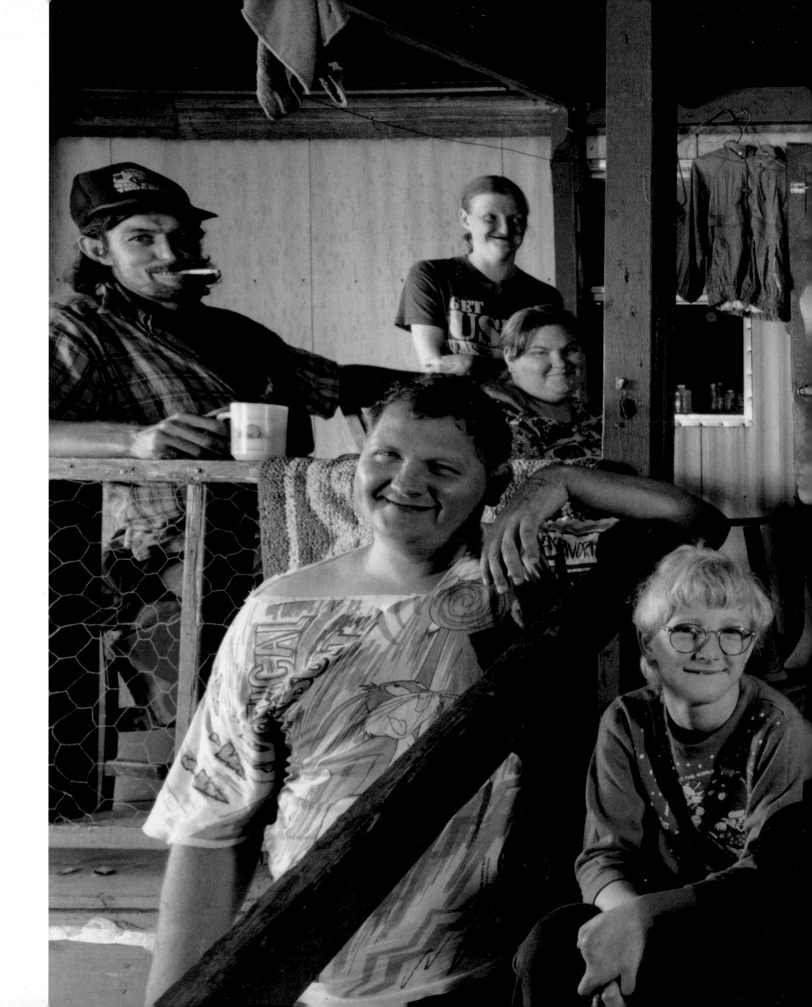

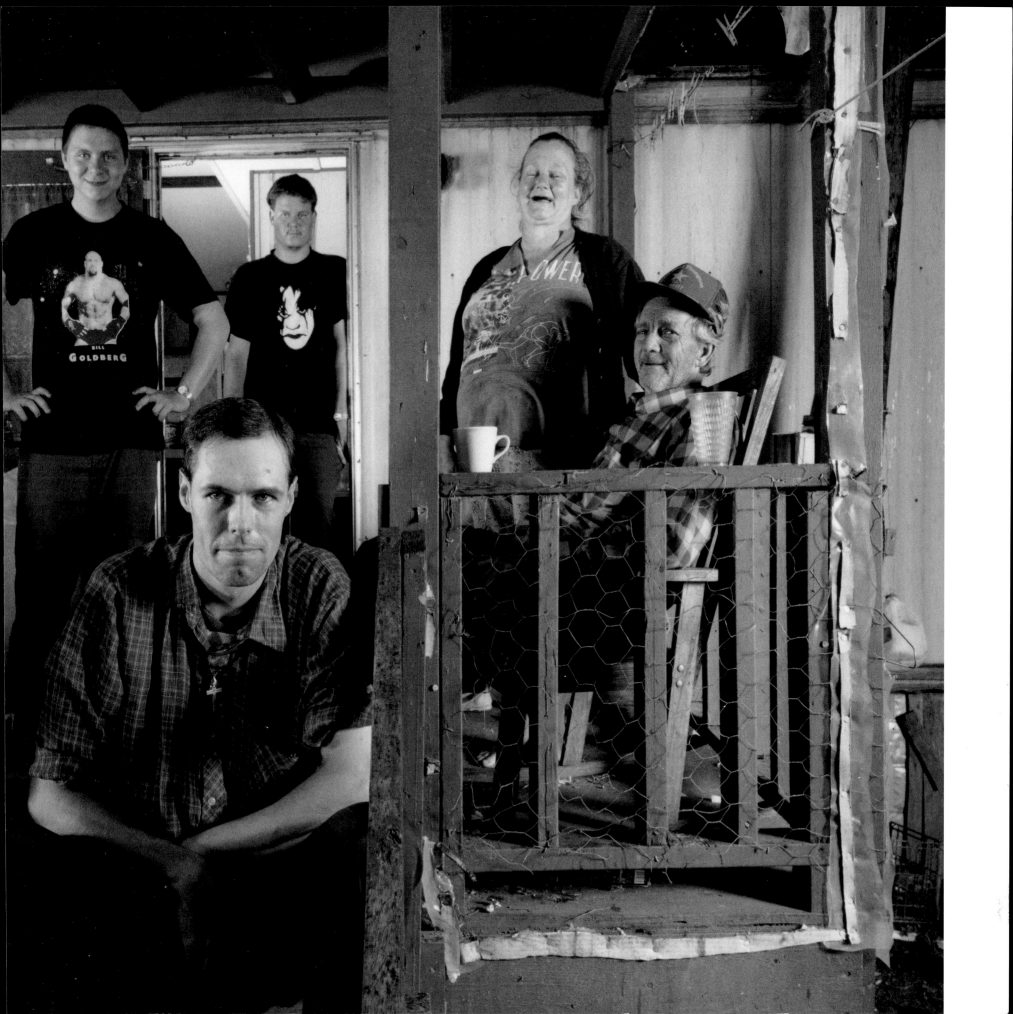

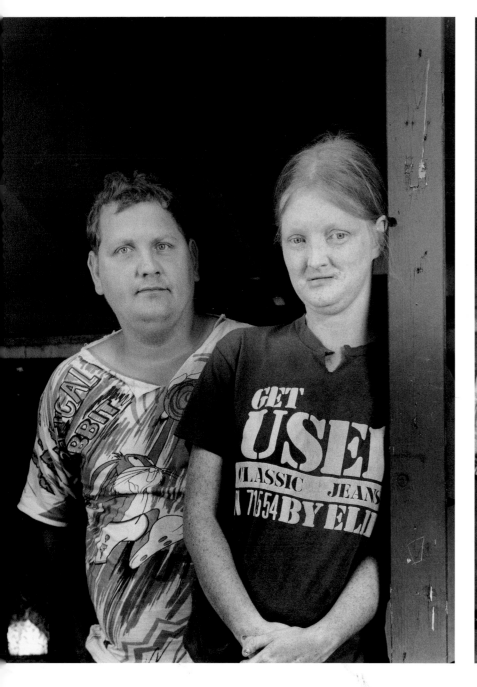

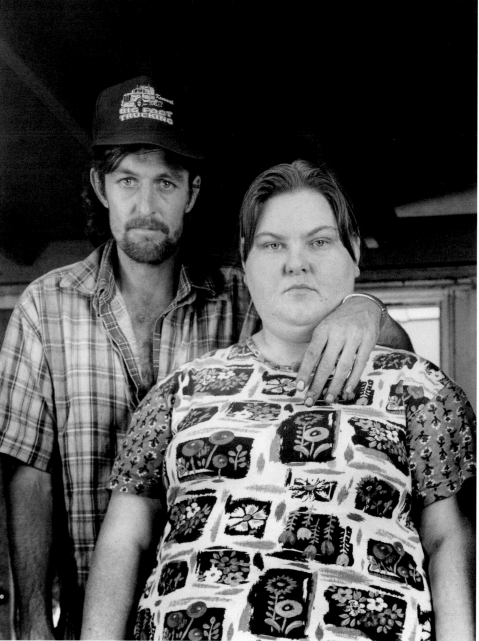

Ray and Debbie *Tina and Randy*

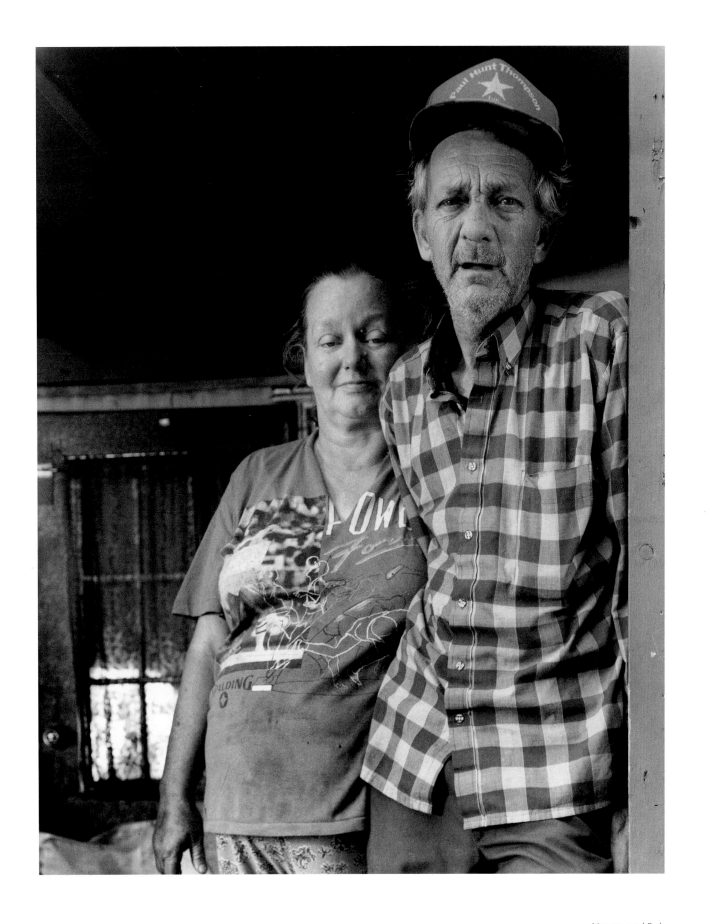

Nancy and Bob **55**

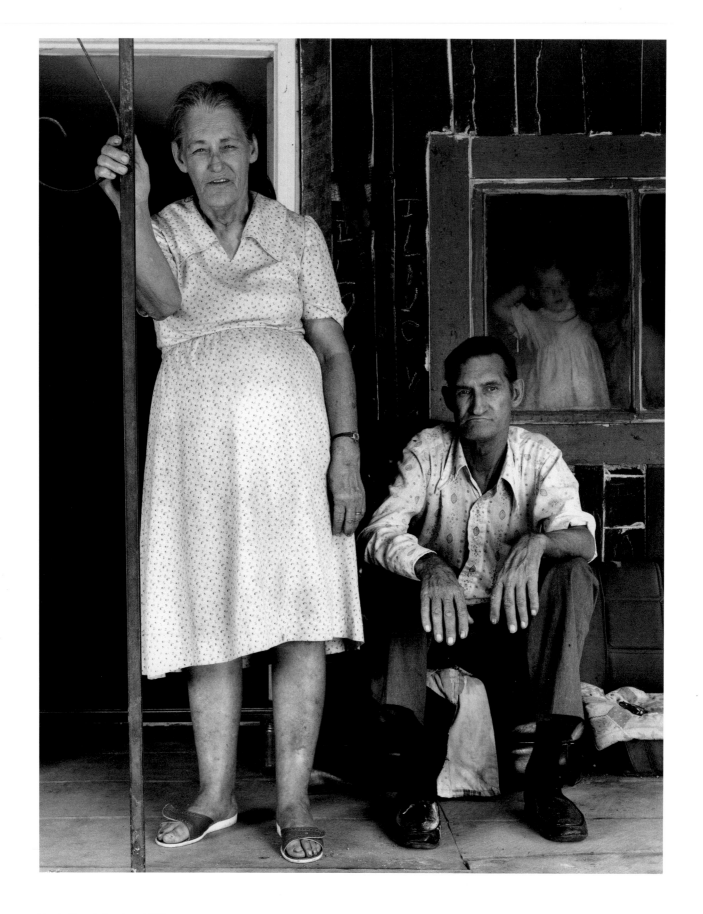

Vertie Slone's Porch 1987

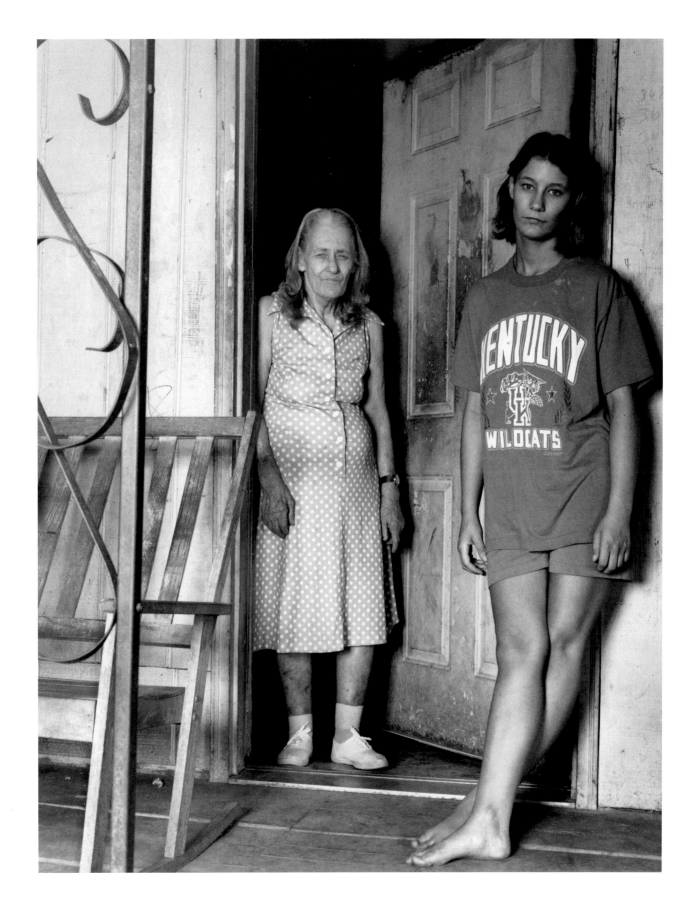

Vertie Slone's Porch 1999

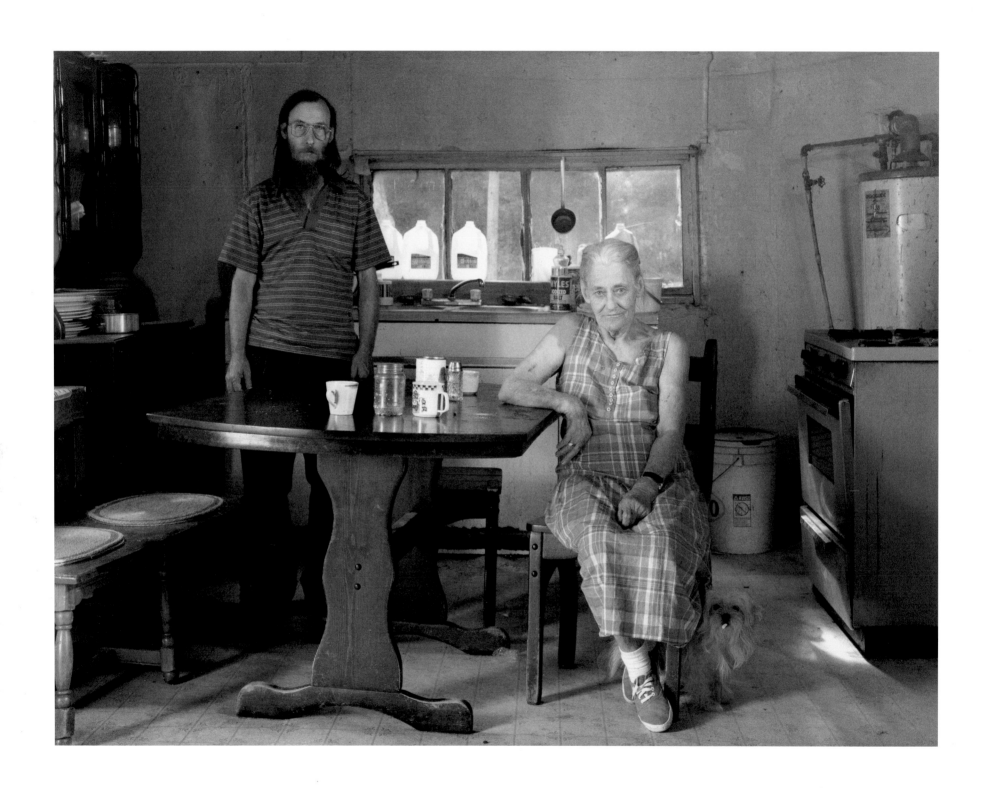

Vertie Slone and Son 2000

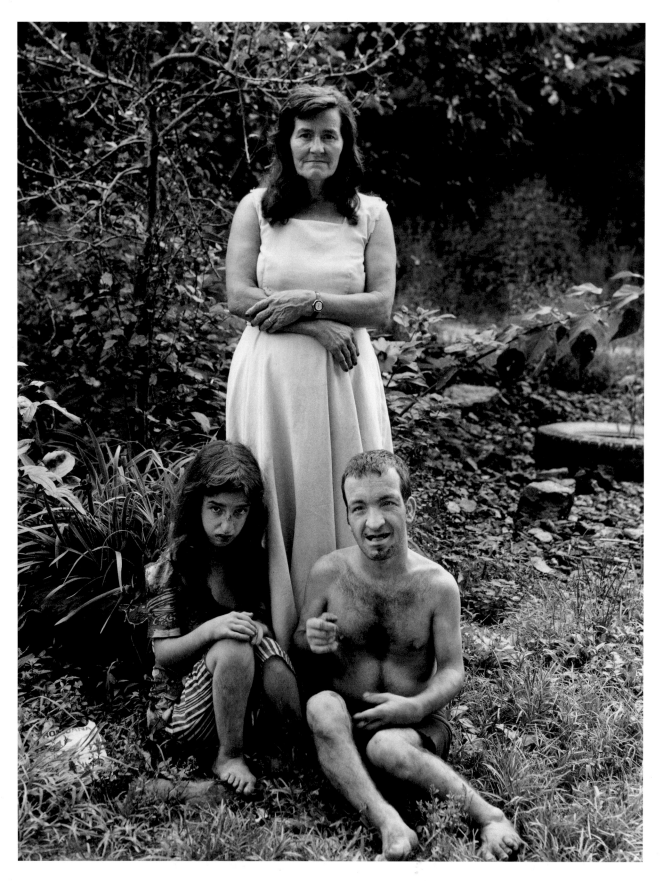

Heddie and Children *1977*

I first learned of the Childers family in 1976 when I met Wendy Ewald who showed me photographs that Freddie and Junior Childers had made for a photo project she was conducting with the children at the Kingdom Creek Elementary School in eastern Kentucky. That project later became the book *Portraits and Dreams: Photographs and Stories by Children of the Appalachians*. Freddie's and Junior's pictures of their family deeply touched me. Wendy told me all about the family, and I asked if she would take me to meet them. When she said she would be glad to sometime, I said, "How about right now—this afternoon?" That was the beginning of my friendship with Wendy and with the Childers family.

The Childers family loved Wendy, and they were very open to me, especially when they learned I had grown up in Hot Spot and had gone to the same grade school some of their children had. Soon we realized that my uncle, Doc Adams, was their family physician and long-time friend. Heddie, the mother, said to me, "You know, you look like that old grouchy son of a bitch." We all laughed. I asked if I could take pictures, and they agreed. That night I visited my uncle and asked him about them. He cursed Heddie's name, grinned, and said, "So you've finally met the Childers family, have you?"

In 1976 the Childers family consisted of Heddie, Burley, and their eight children. Heddie has since died of cancer, and the children have married and had children of their own; yet the nucleus of their family love remains strong. One daughter, Correrine, left the mountains with her husband, Philip, so that he could find work to support their five children. They bought a home in a suburban neighborhood of Crab Orchard, Kentucky, where Philip got a full-time job driving a cement truck. Like Philip and Correrine, many mountain families travel to larger cities in search of work, but most return to the mountains, to the home places they love the most. For four or five years, though, I had missed Philip and Correrine when I visited the mountains, so in 1996 I made a special trip to Crab Orchard to see them.

I had been photographing Philip and Correrine's children since they were babies, and I was struck by how quickly they had grown up. Dressed in baggy pants and T-shirts pictur-

ing their favorite rock 'n' roll bands, the boys were in high school and bigger than I. When Correrine told them that I was the one who had been photographing the family all her life, they started pointing behind me. Turning to look, I saw that the whole living room wall was covered, almost floor to ceiling, with my photographs, pictures of the family that I had taken over the course of more than twenty years.

Enthusiastically the boys asked me, "Where was this taken? When was this taken?" Correrine pointed out their baby pictures to them. As we looked at the photographs of Correrine's physically and mentally disadvantaged older brothers and sister, Homer, James, and Selina, the boys' tone became serious. They told me that their friends had asked about these pictures. If someone made fun of their aunt and uncles, the boys fought with them and didn't invite them back. When Correrine's brothers were in school, they had had the same kinds of problems fighting with kids who made fun of Homer, James, and Selina, which is one of the reasons that the Childers family moved around a lot.

The boys asked me hard questions about why I had photographed their aunt and uncles so much and about what I did with the pictures. I sat down and explained my work as best I could. I told them, simply, that their grandmother had wanted these pictures made, that she believed her children should be recognized, not shunned, and that she and their grandpa had dedicated their lives to caring for these three at home rather than placing them in an institution. The boys knew that Burley was continuing on his own to care for Homer, James, and Selina. I told them that some people might be taken aback when they saw the photographs but that they might also see the love and caring and devotion within this unique family. I explained that, to me, Homer, James, and Selina were true children of God and that ignoring their humanity would be wrong. I expressed my belief that we should all try to accept one another's differences and be nonjudgmental, and I hoped that my pictures would show my view of the love this family had for its own.

Now the Childers boys are grown up, married, and parents themselves, and my work with their family continues. We have become an integral part of each other's lives.

We have had some memorable experiences during these years of making pictures together, and one occurred in May of 1999. That afternoon when I arrived, Burley asked me to photograph his new painting, recently purchased for $350 at a furniture store in Hazard. A reproduction of an eighteenth-century Flemish still life, measuring about thirty-two by forty inches and framed in gilded plaster with lots of swirly details, the painting stood on its own brass easel, a floor model. I imagined it decorating a corner of a rich strip miner's girlfriend's apartment, gaudy red shag carpeting on the floors. Burley had it sitting behind the refrigerator on the worn wooden floors of their house, which had been a store during the depression. When I asked him why he had bought it, he said, "I just really liked it."

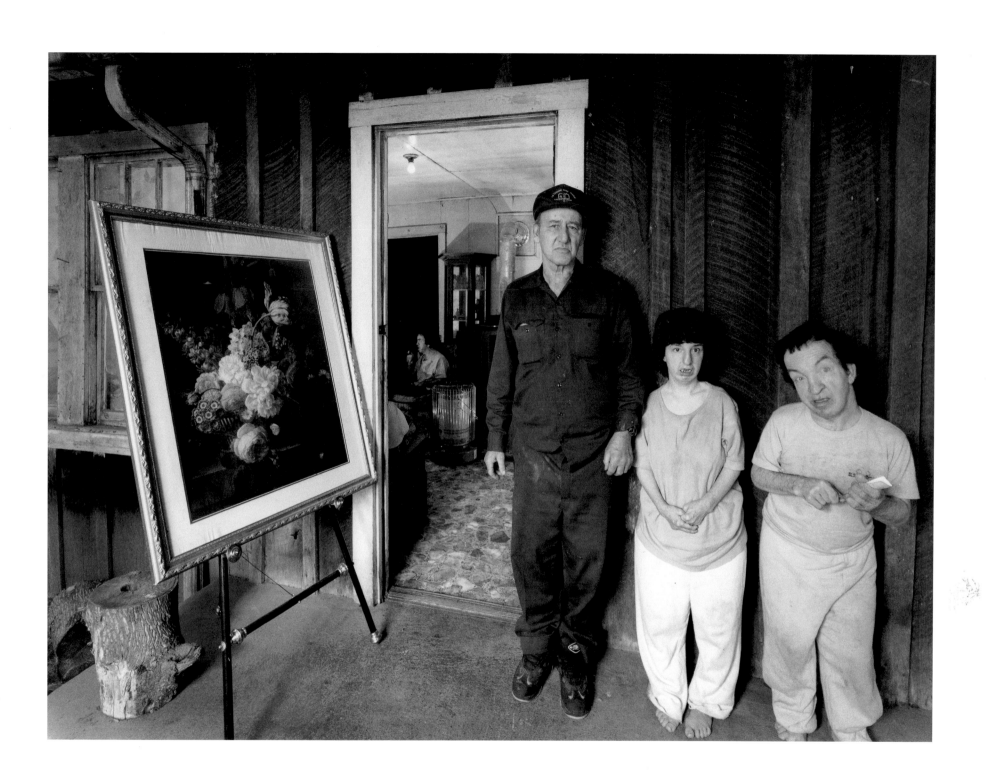

Burley with Picture and Children 1999 **63**

We carried it to the back porch, where we set it up for a photograph. I stood my tripod up in the yard, with strobes outside to light the porch and one battery pack inside to illuminate the living room, where James sat in front of a blaring TV he wasn't watching. I began adjusting my camera. Junior, another of Burley's sons, dropped by with his wife, Rosa Lee, and son, Roy Lee, just as I had begun to position the family for the photograph. We greeted each other, shaking hands and hugging. Then it began to rain, one of those light spring showers with the sun shining through. I covered my camera with the drop cloth, turned the reflecting umbrellas up over the lights, and waited for the weather to clear. As I stood in the rain looking at the scene in front of me, I knew that this was the photograph I really wanted to make and that the camera had to be exactly where it was, two feet out in the yard—this moment, I believed, could never be duplicated. Studying the mountains and the sky, I silently cursed the rain. Then it let up. I uncovered my camera, readjusted my lights, and moved Homer and Selina into place beside their father. Junior and I placed a fire log in the bottom left corner to help fill in and balance the composition. I loaded the Polaroid back and made the first check print just as the gutter began to leak rainwater right onto the middle of my camera. I couldn't move the camera without losing the photograph, so, reluctantly, I found the cloth and covered the camera.

Thinking of the photograph I might never make, I looked at Burley. He kind of grinned and shrugged his shoulders, and we all burst out laughing. We remembered the Polaroid; it was overdeveloping. I pulled the backing, and the image looked as good as what I had envisioned. Then the water from the gutter stopped, and so, it seemed, did time. With James still unmoving in his chair and everyone else in place, I calmly took the picture. In the next moments I looked at the mountains and thanked God for giving me this photograph.

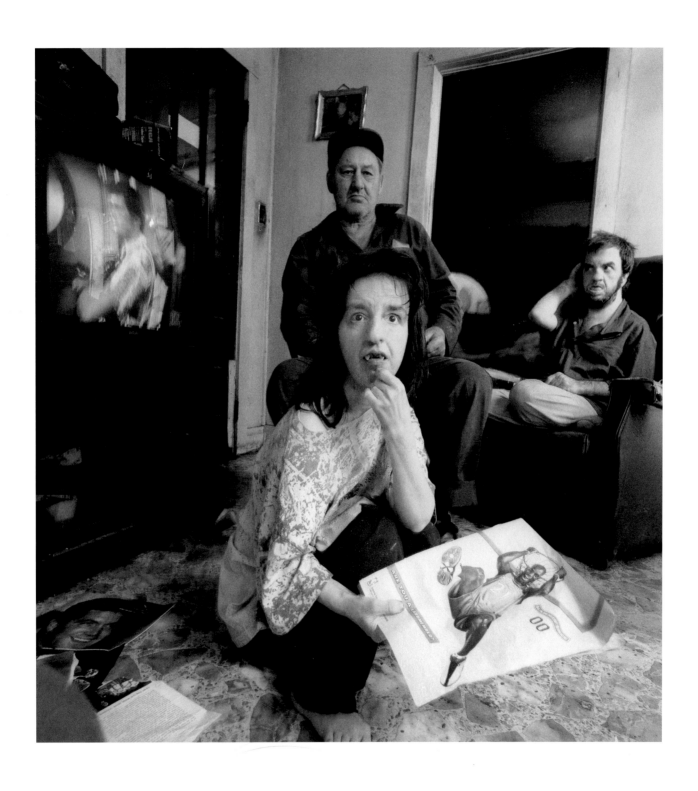

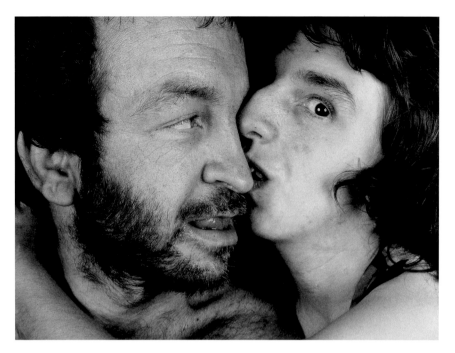

The Kiss 1986

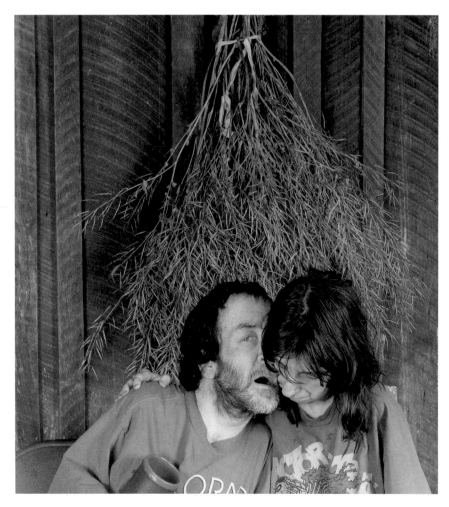

The Kiss 2001

Return, Return

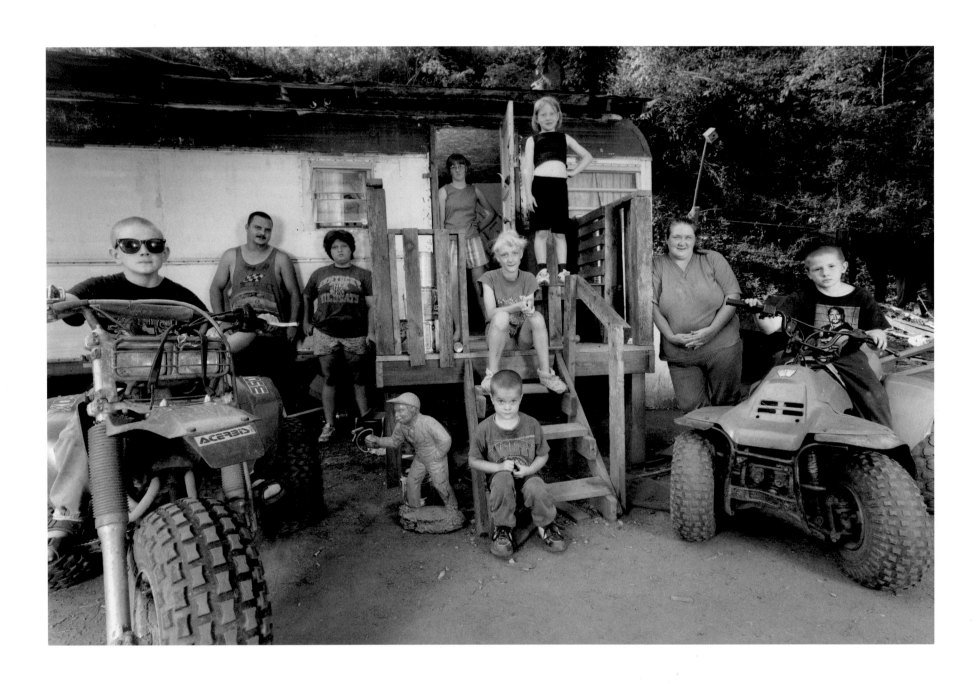

William and Patty with Family 1999

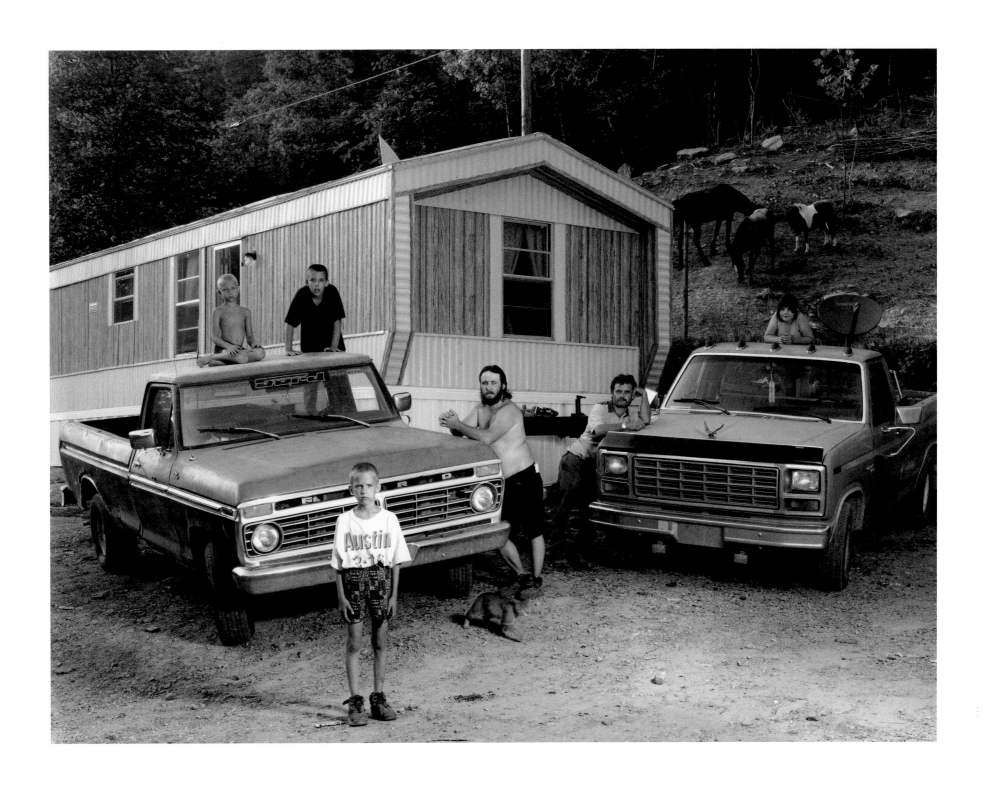

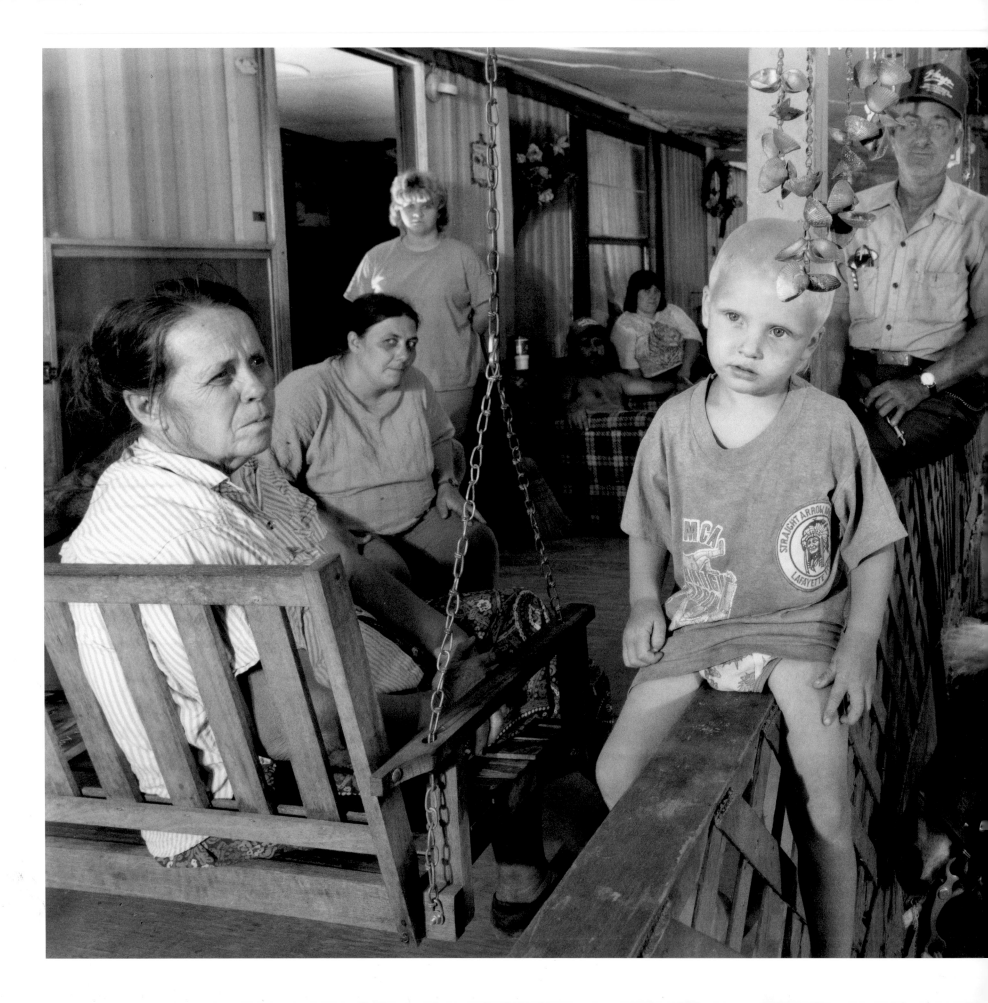

The Nobles' Porch *1999* **71**

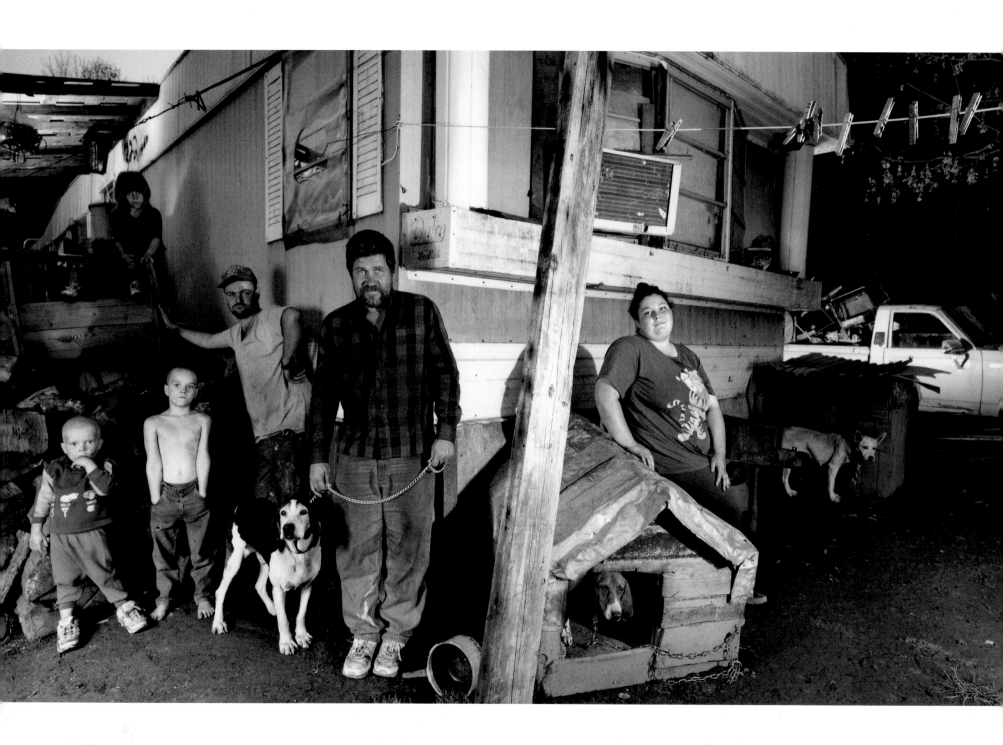

Estill with Family and Dogs 2000

In the fall of 2000, when I go to visit Estill Reynolds and his family, they are living in Weeksbury, a small mountain community in Kentucky's Floyd County. Weeksbury has a post office and five churches, mostly Baptist or Pentecostal Holiness, all painted pristine white. It also has a general store with a beer and liquor license and two gas pumps, a dairy bar (open in the summers only), and a family restaurant that serves instant frozen pizzas to go. Recently a BP chain gas station has opened in the community. I met and photographed Estill with his wife, Mary, and their six children, Martha, Kathy, Lisa, Claudeen, Billy Ray, and Charles, over two years ago, when they lived at Price, Kentucky. They were neighbors of my friends the Hall family, whom I had been photographing for some years.

It is a fine October afternoon, with crisp light and long penetrating shadows, when I finally find Estill's new home place. The family now rents a brown-and-white trailer, probably a sixties model, which has a hand-built wooden porch covered with tin roofing. The porch's foundation consists of stacked gray cinder blocks. More blocks have been placed at the upper end to make steps. It's a solid, practical structure, built with children in mind.

Estill greets me from the porch, inviting me in. Several of my photographs hang on the walls in their living room. After visiting and distributing photographs that were taken last summer, I ask if I could look around their new place for an interesting spot where I might make some pictures before dark.

Estill and the kids walk around with me. In an abandoned lot next to his trailer, Estill has several dogs tied and chained to various little doghouses. As we get closer they start jumping and barking loudly; one leaps onto his house and yaps. Estill shows them all to me, telling me their histories and explaining whether they are skilled hunting dogs or just good pets. We walk behind his trailer and meet his daughter and son-in-law, Lisa and Johnny Newsome, both in their mid-twenties, who live in a trailer behind Estill's. They, too, have several dogs chained to individual doghouses in their backyard. I ask Johnny how many dogs they have, and he waves his arms. "You see 'em all there. I don't know how many there is." They are barking, howling, and jerking their chains so loudly that I can hardly think. Nevertheless, the backyard is where I imagine an environmental

composition that I want to photograph. When I tell them my idea, Johnny and his wife share my enthusiasm.

I begin unloading my view camera and equipment from the car. Johnny goes inside to plug in my extension cords for the strobe packs. Lisa goes to get a shovel to remove some of the dog droppings in the area where I want to set my camera. We have to be careful where we lay the light cords. I ask if it is okay to turn one of the doghouses around so that it is facing the camera. We leave the old beagle hound inside while we move his house, careful not to disturb him too much. I find out that he is one of Lisa's favorite dogs, and she is pleased that we will photograph him and his house.

All of my equipment is now in the middle of the yard, and I have no clean place to set up my Polaroid film, negative film backs, and lens bags. Estill and Johnny get a flat-roofed doghouse and bring it over for me to use as a table. Some of the dogs are moved farther back and chained to the fence so that we can hear each other talk. A dog breaks loose, running through everything before he is locked up in another type of pen. I try not to breathe through my nose, as the smell in the yard is challenging.

I set my view camera on the tripod and frame the scene as I have envisioned it. The middle doghouse is in the right place. I have to work fast, as the daylight is beginning to disappear. We place one light pack on the porch in the left of the composition; I will use a photo slave to fire this light later. On the right side of the composition, I place a light on a stand and reflect the light off the back of the trailer and onto a Toyota truck in the background; this light too is slaved. Then I place two stands in the yard with lights on them and umbrellas aimed toward the middle area of the composition. I test all lights that are set to work with AC current and slaves. As the lights flash, the dogs bark louder. I am using three different strobe packs, synchronized with four different light sources and some daylight.

Finally, I am ready to start making some Polaroid images. I tell everyone to stand where he or she would like to be in the picture. Mary and her daughter Martha decide they don't want to be photographed and go home to start supper. The children need to be placed and told where to stay. We make our first Polaroids. I tell people to remember where they were so we can make more pictures later, knowing no one will find exactly the same spot. We look at the Polaroids together. Estill disappears, returning shortly with a fourteen-year-old hunting dog, his favorite, with which he wants to be photographed. Claudeen starts to climb up the wood pile and falls down, crying, but she is okay; someone helps her get to the spot she wants to be in for the photograph.

We start again to make some more Polaroids. After a couple have been processed, Billy Ray wants to see them and runs toward me, jumping and grabbing onto the makeshift table where I'm working. He almost turns the doghouse/table over, with all my equipment on it. I yell at him to leave. Estill grabs him, scolding. He goes back to get in the picture. The

dogs keep barking, and the sunlight is disappearing. I adjust the lights a bit now and ask everyone to pay attention. We are finally ready to shoot film. I direct everyone to move a little, left or right, this direction or that. Everyone looks at the camera now, and we will take several films. Only one negative has all three dogs looking at the camera, and that is the photograph that will be published.

The set-up time for *Estill with Family and Dogs* has probably involved about two hours; packing up amounts to another couple of hours. It is important to visit at Lisa and Johnny's for a while before leaving; they have been very helpful. I coat several 4 x 5 Polaroids to leave with the family until the next visit, when I can bring back prints. I will stop at the Isom car wash on the way home that night to clean my shoes off thoroughly.

On May 2, 2001, during my next trip to Kentucky, I find Estill and his family visiting his other older married daughter, Kathy, who lives with Daniel in a trailer right beside the road, just up a little way from where Estill lives. Kathy and Daniel rent from the same landlord Estill does. I give the family the pictures we made the fall before, which they like. I also give them a second copy of my book *Appalachian Legacy*, as Mary has requested. (I gave a copy to Lisa last fall.) I tell everyone that I really like the photograph *Estill with Family and Dogs* and ask if they will sign model releases so that I can exhibit the photograph and use it in my new book. I explain that the children's releases have to be signed by the parents. Everyone agrees and signs.

Kathy and Daniel show me around their new rental home. We look for a place where we can make a new photograph. Everyone there has been photographed by me before. The only thing I find of interest is in the yard out beside the road. A sign hanging on the fence post says, "NO Trespassing—Police Take Notice." Mary is dressed up, having just been to town, and I ask her if I might take her picture beside this sign, since she was not photographed last fall. She says she loves my pictures and would like to be photographed with her daughter and son-in-law. I move my car onto the edge of the road so that I can unload my equipment, there being limited space for parking at their trailer site.

While I am setting up my camera and lights beside the road, three teenage girls walking by in jogging outfits stop and ask me what I am doing. I explain to them that I am going to photograph the family who lives there. They see my Massachusetts license plate and ask me where I am from and if I work for the newspapers. Despite my telling them that I grew up in Letcher County and am photographing for myself, one of the girls tells me I don't have permission to take pictures there and should leave. Estill speaks up, saying it's okay with him, that he has known me for years, and that he has shown some of my photographs to the landlord, who thinks it's all right, too. The girls leave indignantly. Mary

says that one of the girls is the landlord's granddaughter and that her mother puts Estill's family down all the time. "They act like they are better than us," Mary says.

About a half hour later, while I am photographing the family, a new red Jeep Cherokee pulls up beside my car and a woman gets out. The three teenage girls are with her. She is dressed in a blue nurse's uniform and wants to know who I am and what I am doing there. She does not introduce herself. Estill and Mary, knowing her, try to explain. She cuts them short, saying, "I'm not talking to you. I want to know who he's working for."

She continues talking, not really listening to me. "You should go down to the Bluegrass and photograph the racehorses," she says. "If you want to make pictures of Kentucky you should go there to make things look good." Finally, she pauses a bit, and I get my book out of the backseat of my car, opening it and showing her my own family photographs, explaining to her that I was born and raised here in the Kentucky mountains and that I believe it is my right and duty to photograph here more than anywhere else.

When I tell her that Estill and his family are my friends and that their pictures are going to be in my new book, she responds, "Well, why didn't you come and photograph my house?" I say, "I don't know you. We've never been introduced." Recognizing that she is making no headway either with me or with Estill, she tells me that I don't have permission to photograph and must leave. I explain to her that, as I understand the law in Kentucky, if a renter invites you onto his or her rental property and says it's all right to take family photographs, you do not have to get permission from the landlord. Estill tells her, as he told her daughter, that he has in fact gotten the landlord's permission.

Then the woman asks me if I have heard about how Hobert Isom in Letcher County killed a filmmaker who was trespassing on rental property and making movies without permission. I smile. "Yes," I say, "I know all about it. Hobert was my third cousin. The film-makers were wrong in what they were doing, but so was my cousin Hobert for killing the man."

"Well," she says, "have you seen the 48 Hours TV show called 'Muddy Gut,' filmed just a couple miles from there? I hope you aren't going to do anything like that. That was nothing but lies to make Kentucky people look bad." She gets in her car and leaves. "Thank you for not shooting me," I call after her.

Mary explains the situation to me. "They live in a big brick home and treat us like we were three feet tall. They come around and ask us to mow their grass in the summer heat and offer to pay us five dollars per hour. They lie about us all the time. We hope you can sell our pictures for a thousand dollars apiece. We enjoy you coming around and like your pictures. Please give us another copy of your book. It shows how we was raised, and we like that. Our landlord's daughter will one day inherit this property. She acts better than everybody, and someday she will make us move. We don't know where we'll go then."

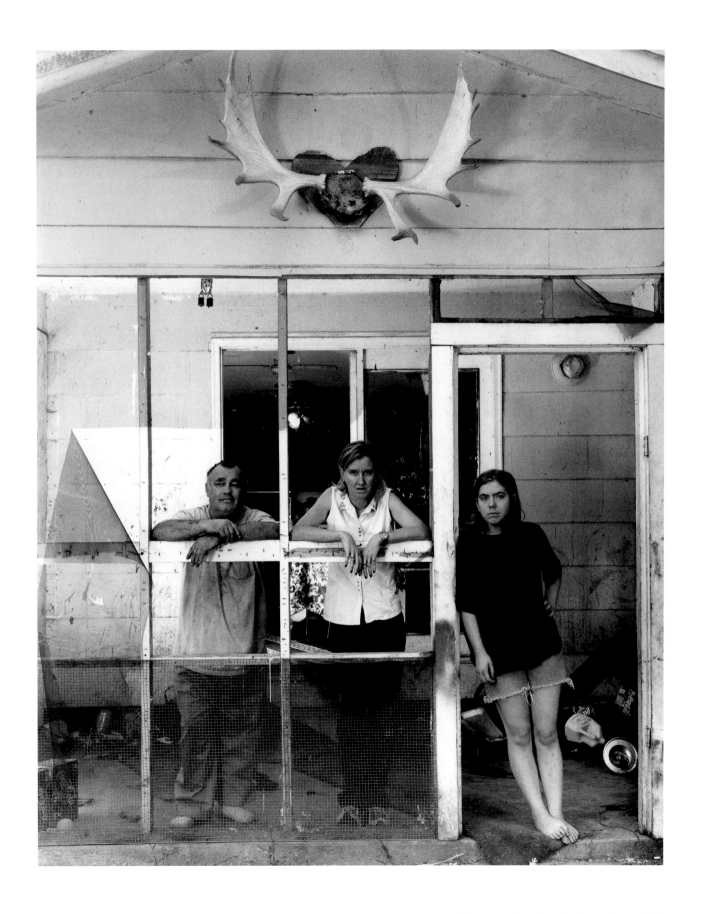

Shirley and Family with Moose Rack *2000*

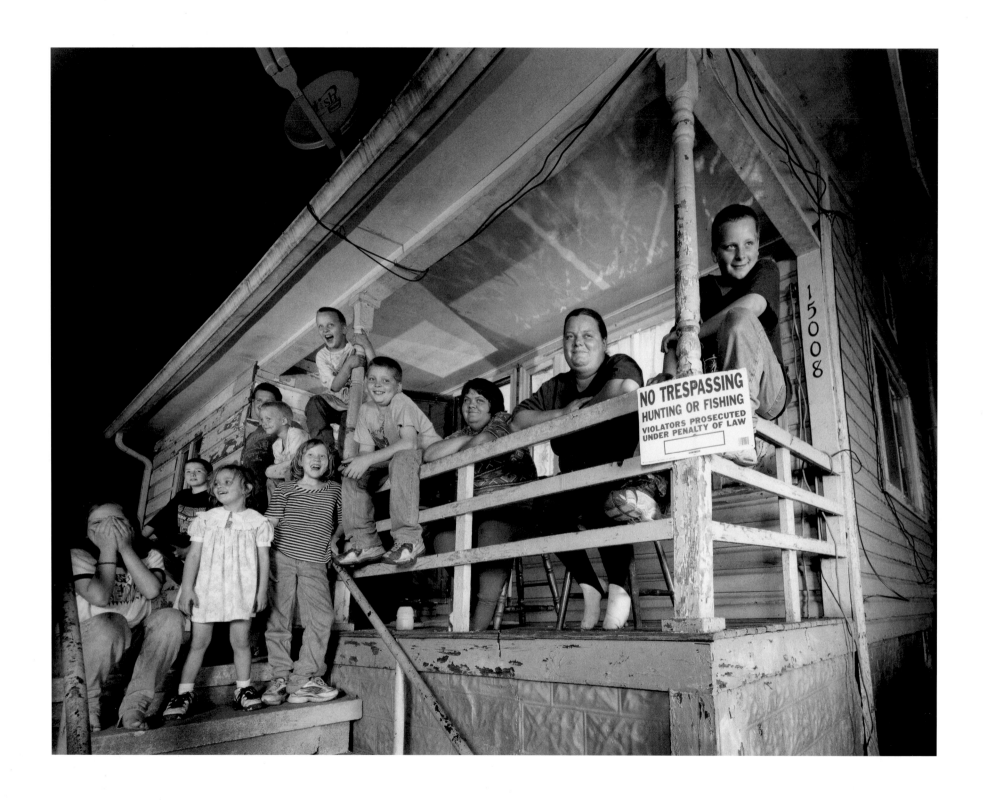

Richard and Lola with Family 2000 >

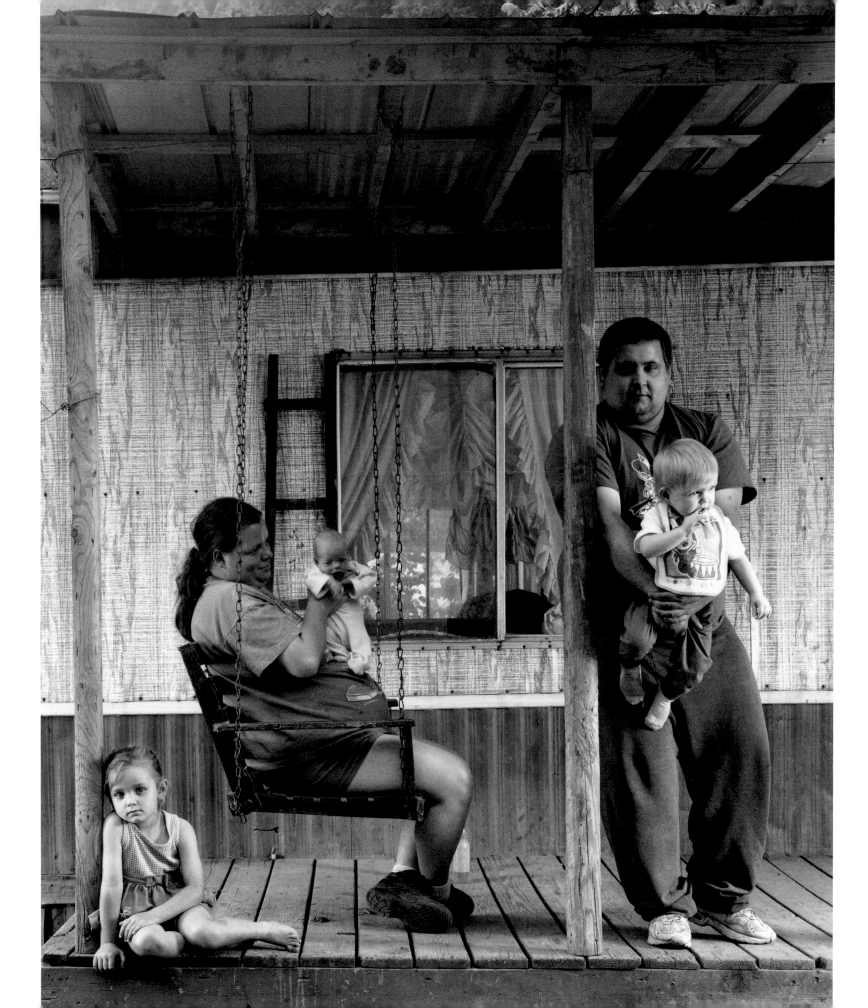

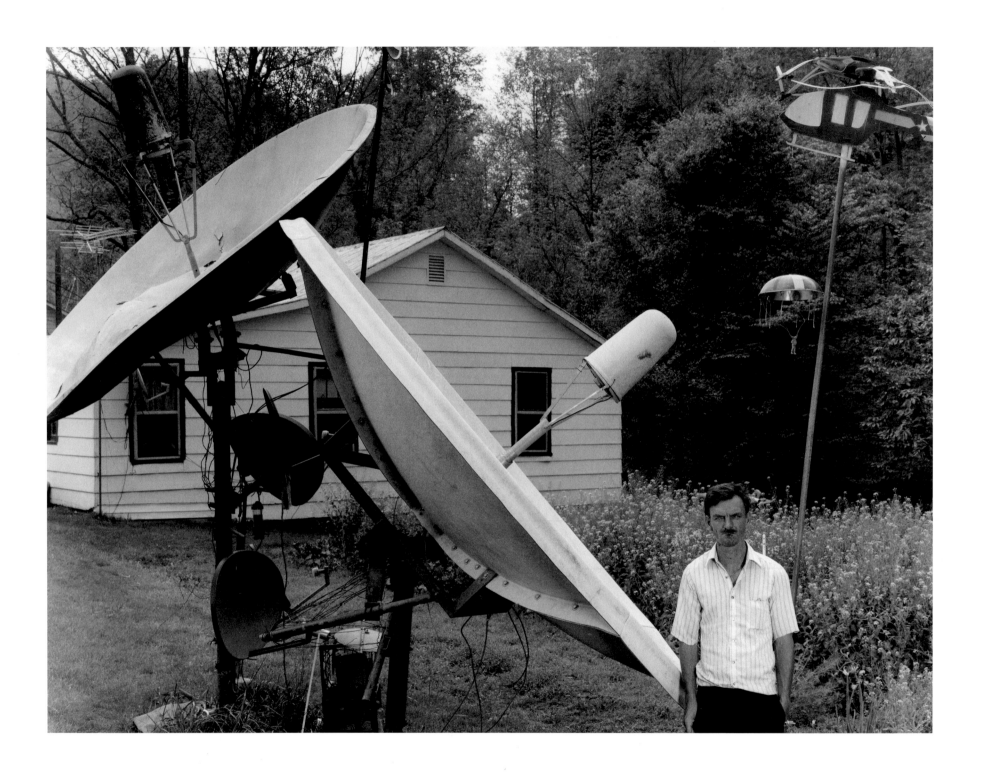

Paul with Satellite Dishes 2000

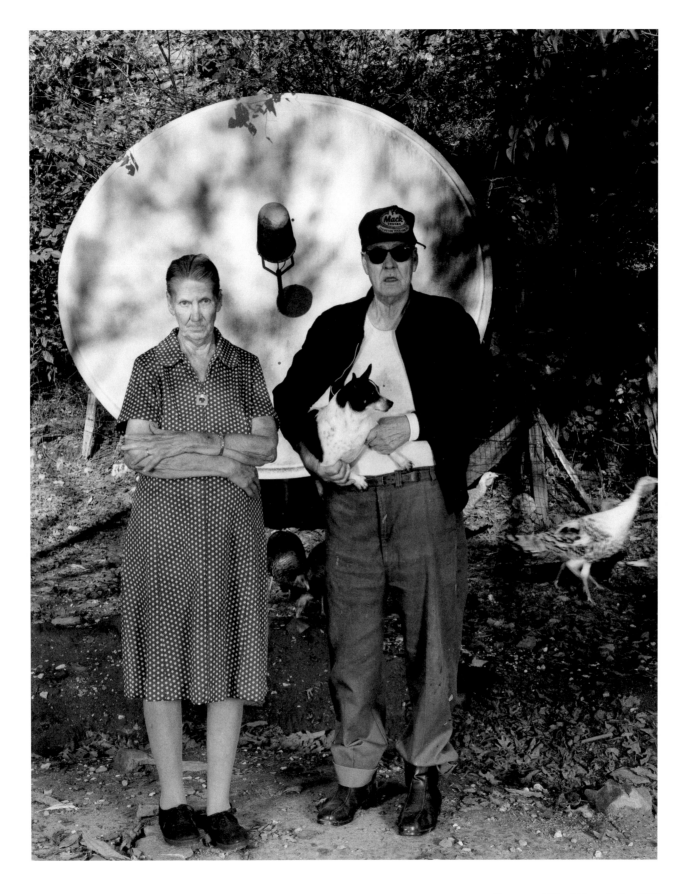

Peggy and Albert Campbell 1999

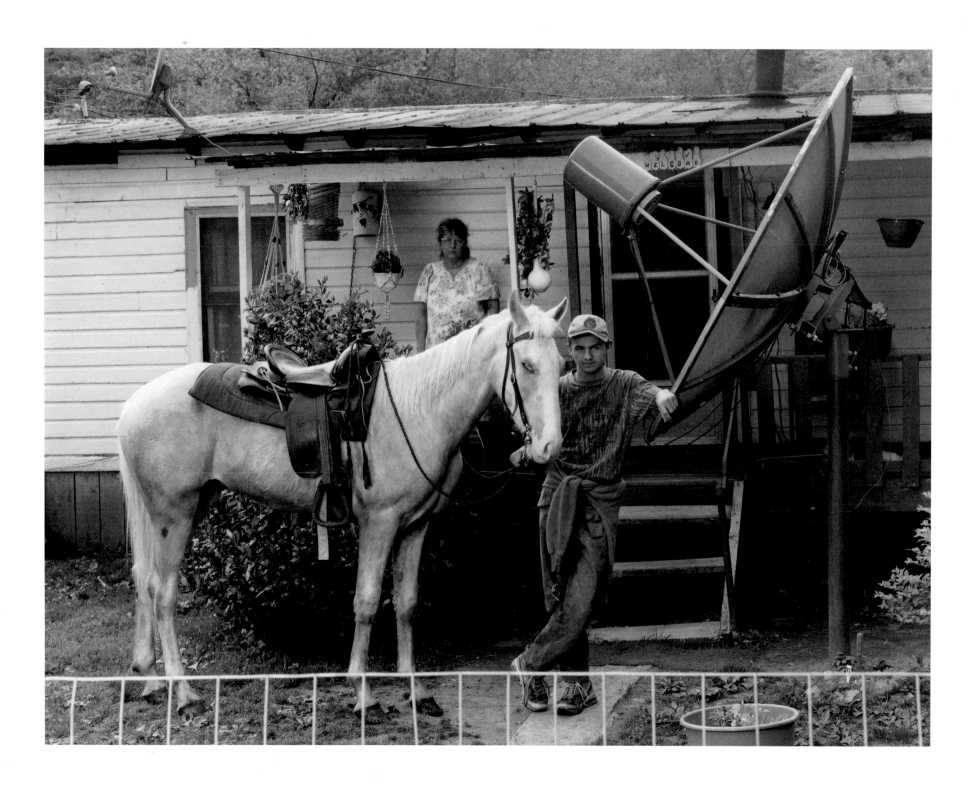

The Ned Yard 2001

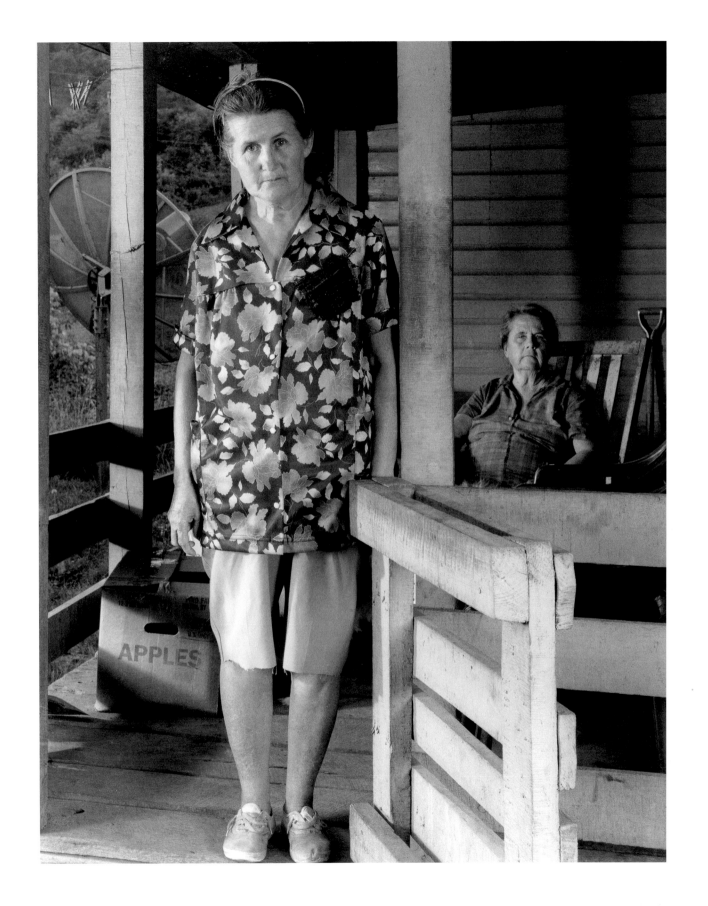

Laura and Rhoda *2001*

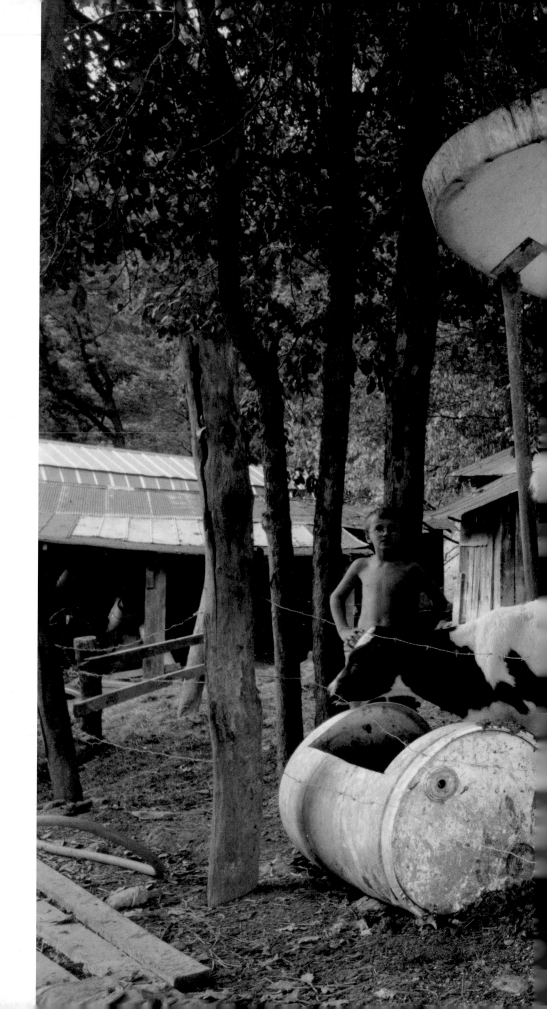

Donnie with Baby and Cows 1999

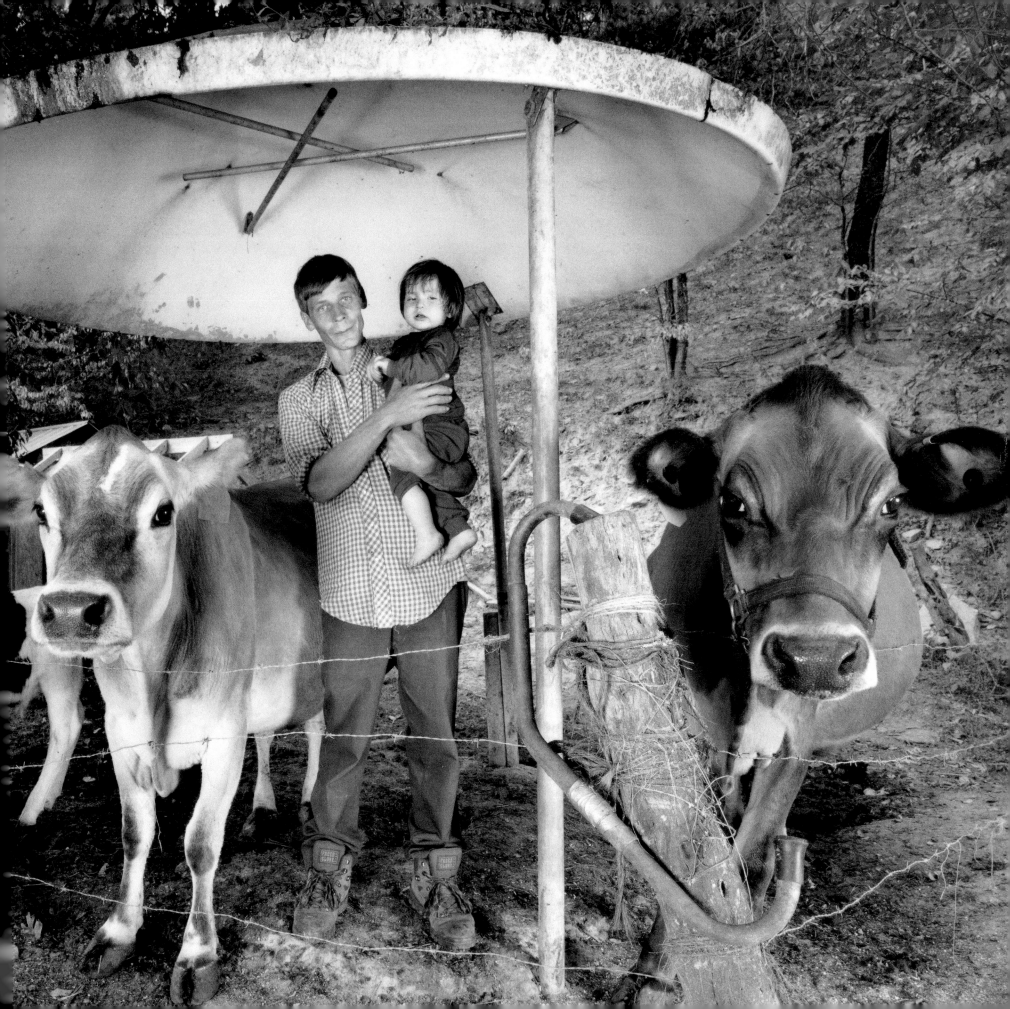

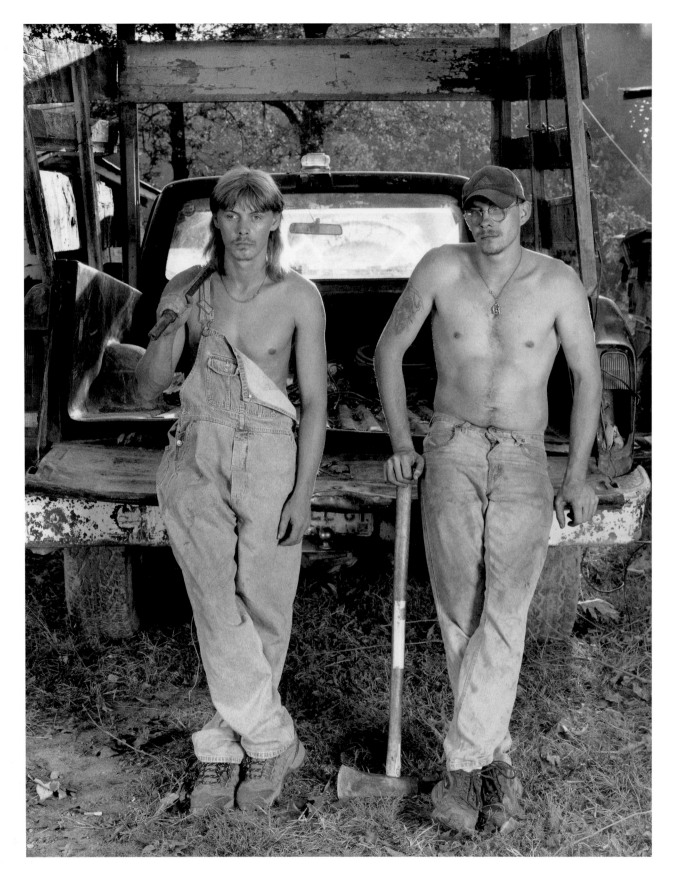

Bruce and Eli 2001

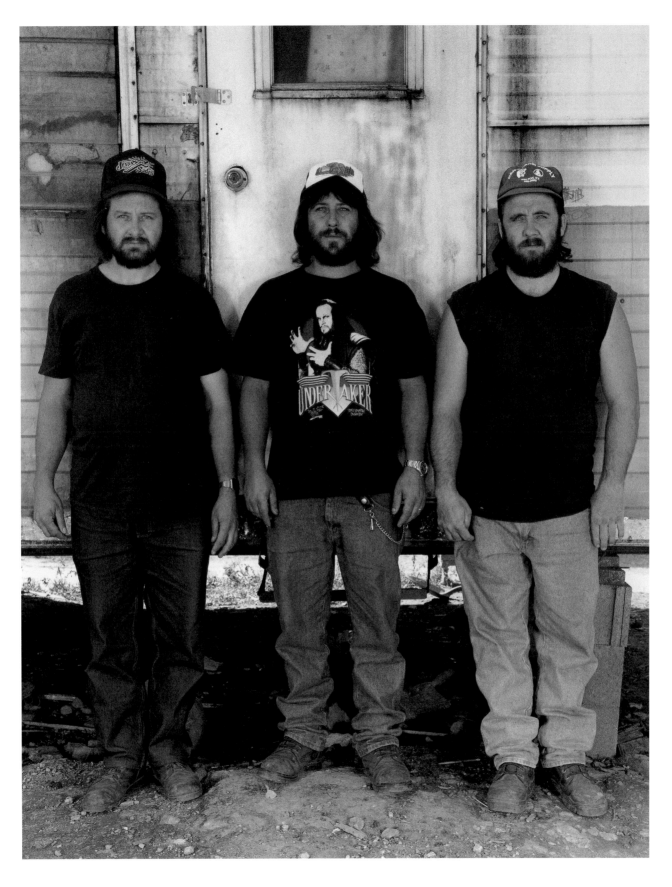

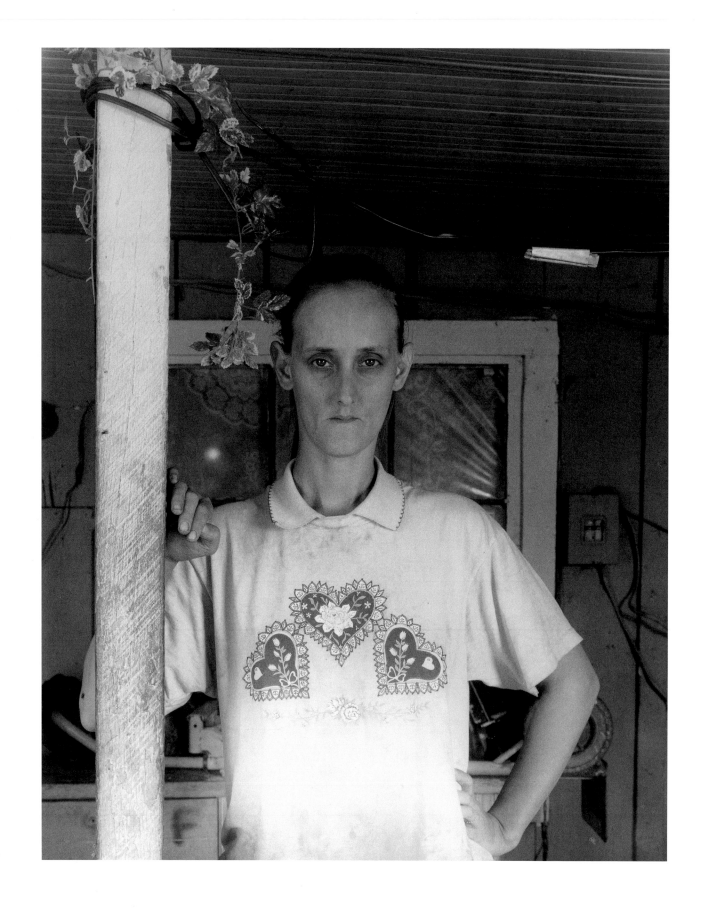

Belinda 2002

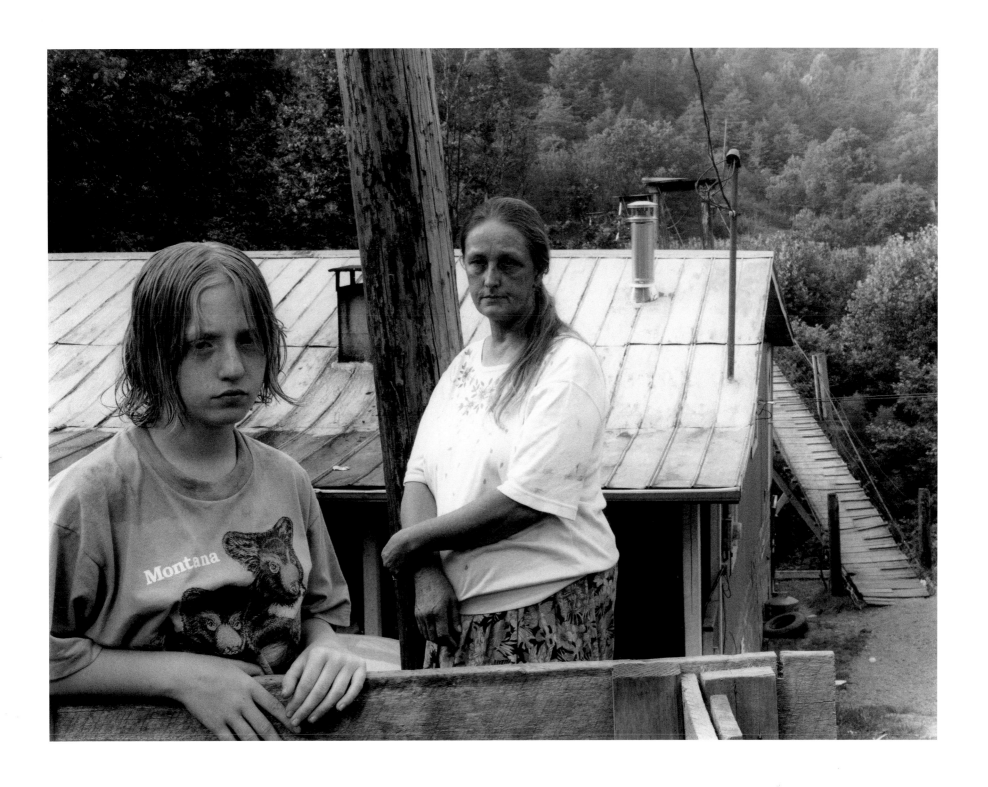

Sally and Geneva 1997 **89**

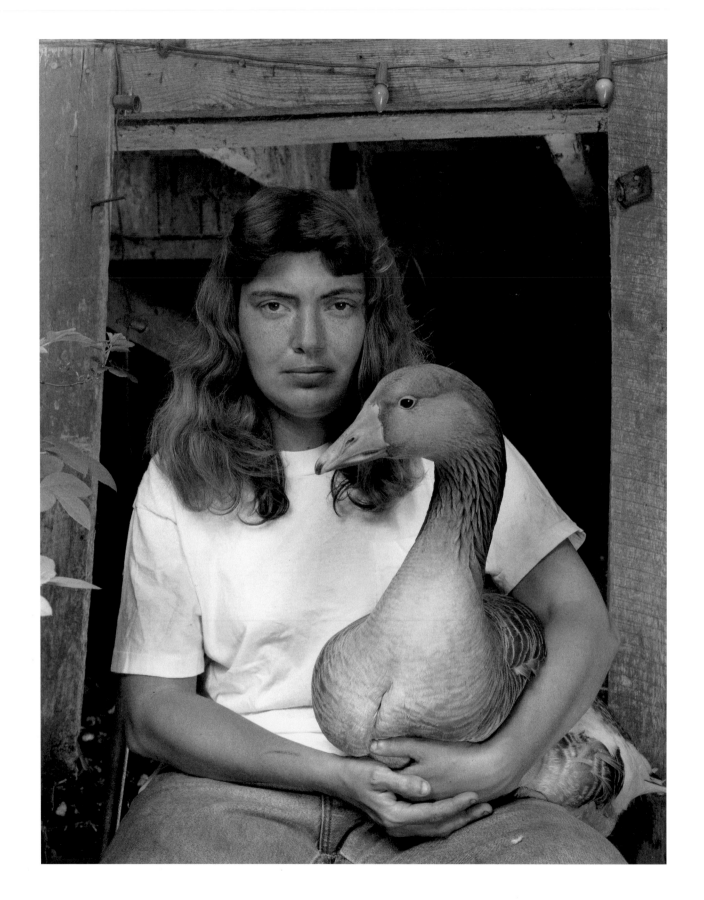

Lila and the Goose *2002*

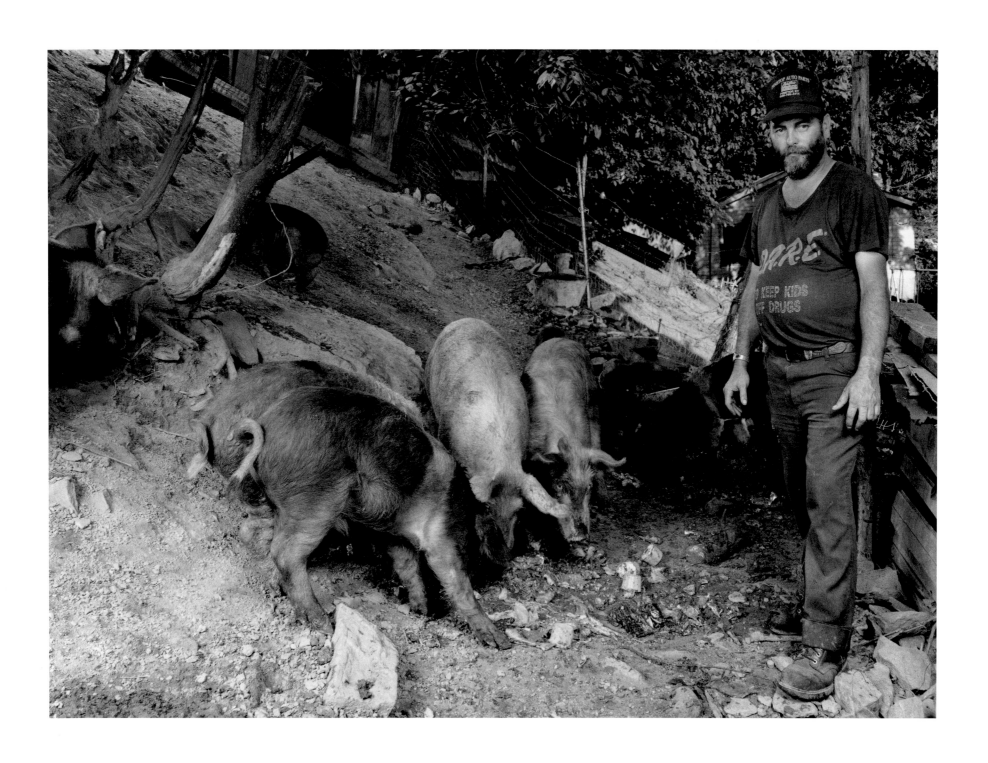

Bobbie in Hog Lot *1997*

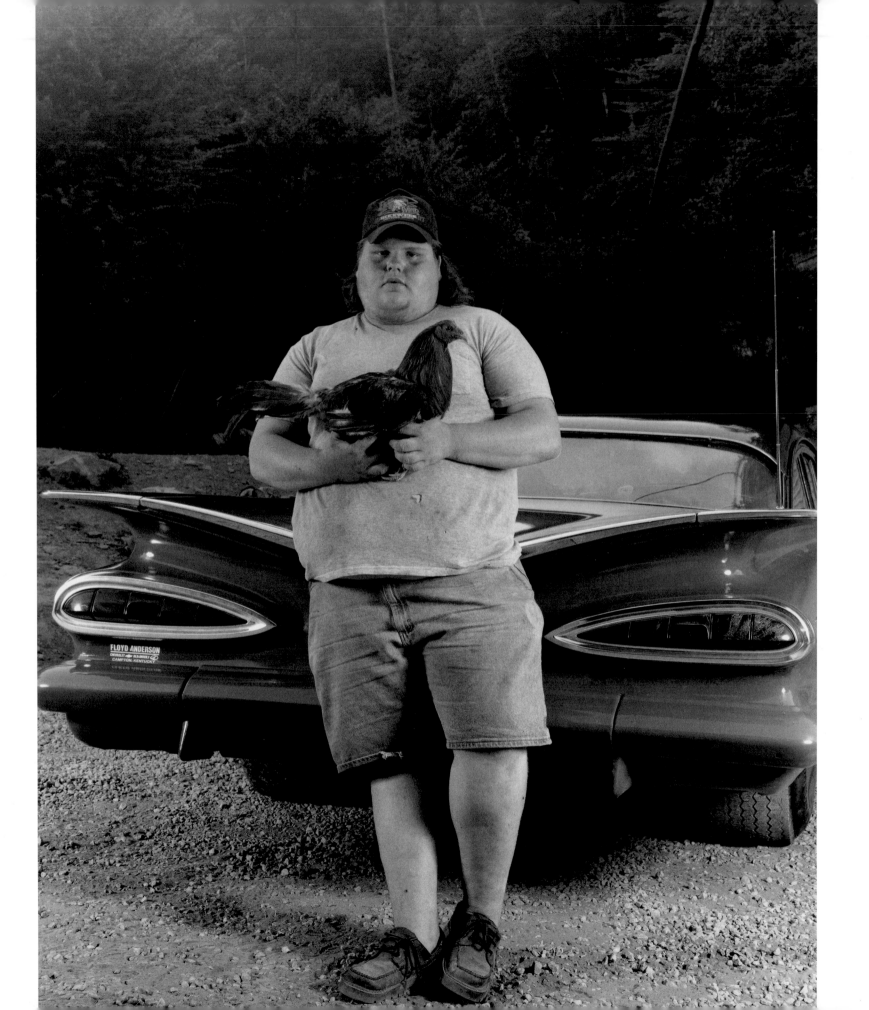

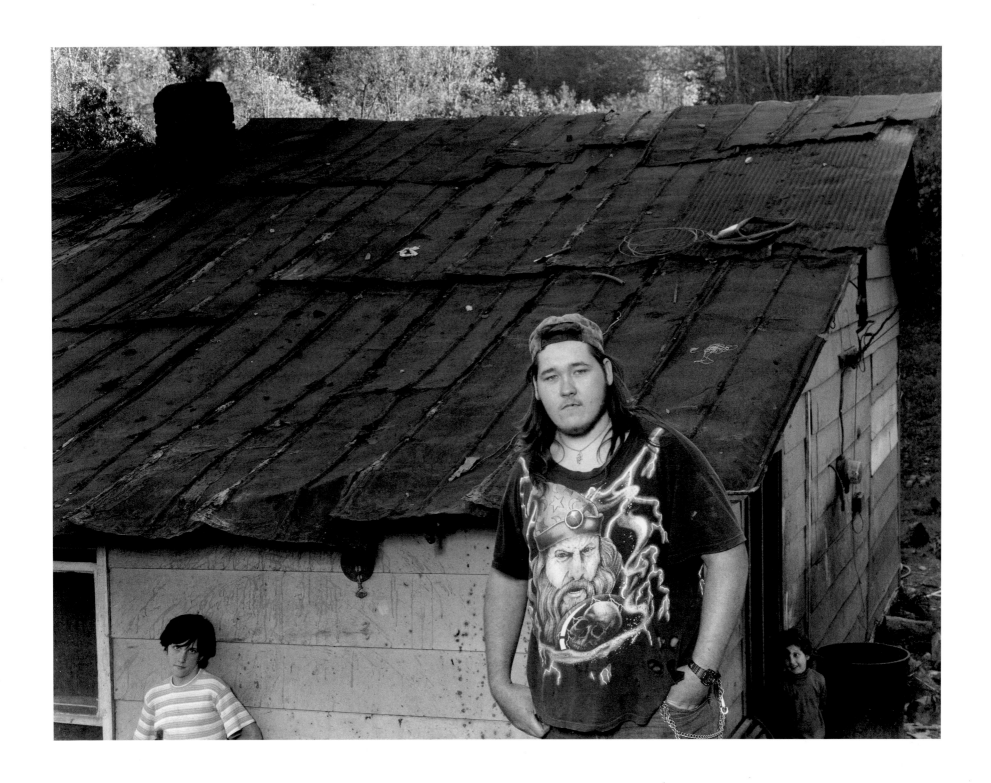

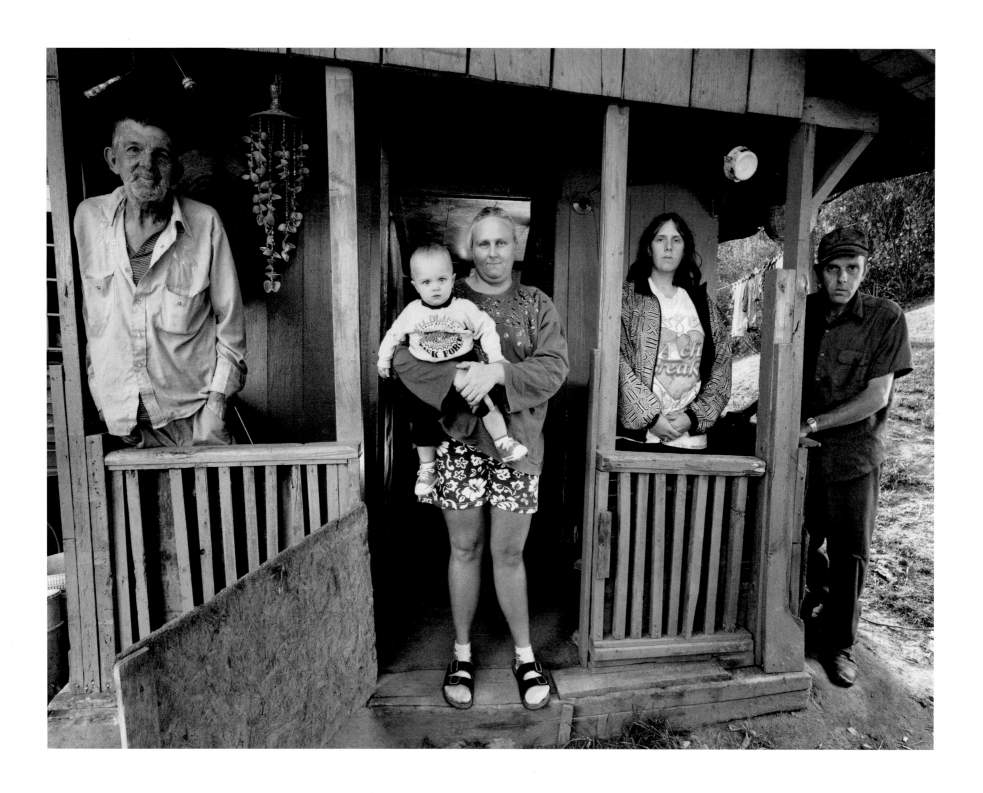

Bud Collins and Family 2001

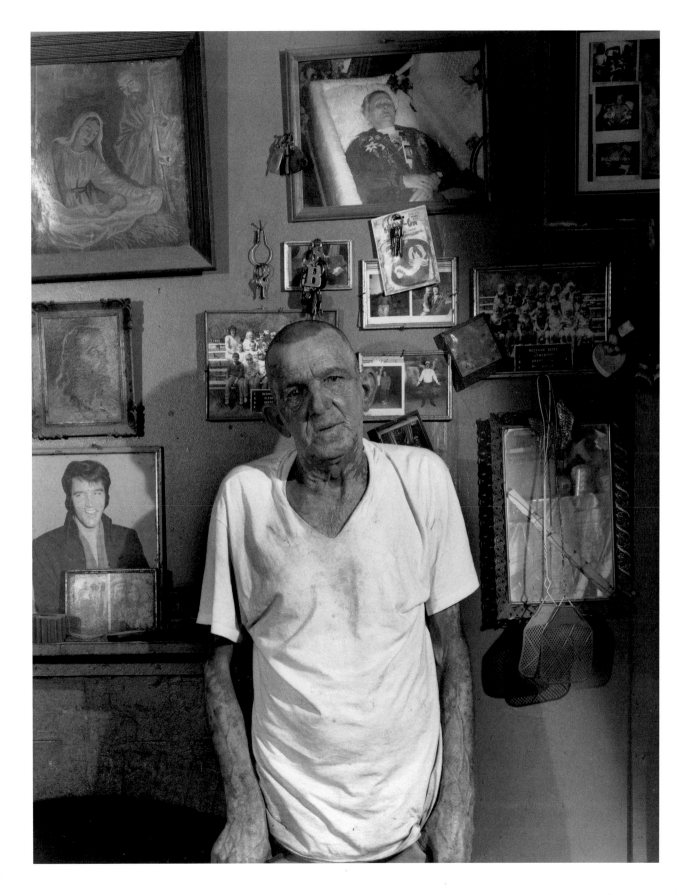

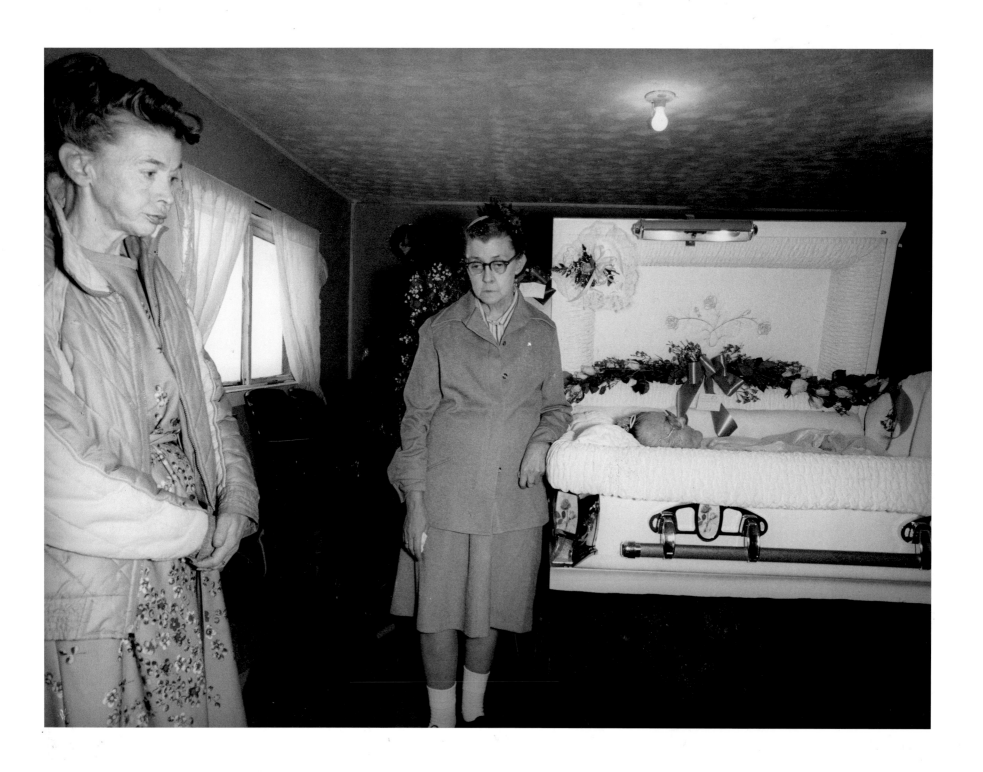

Tilda's Funeral 1999

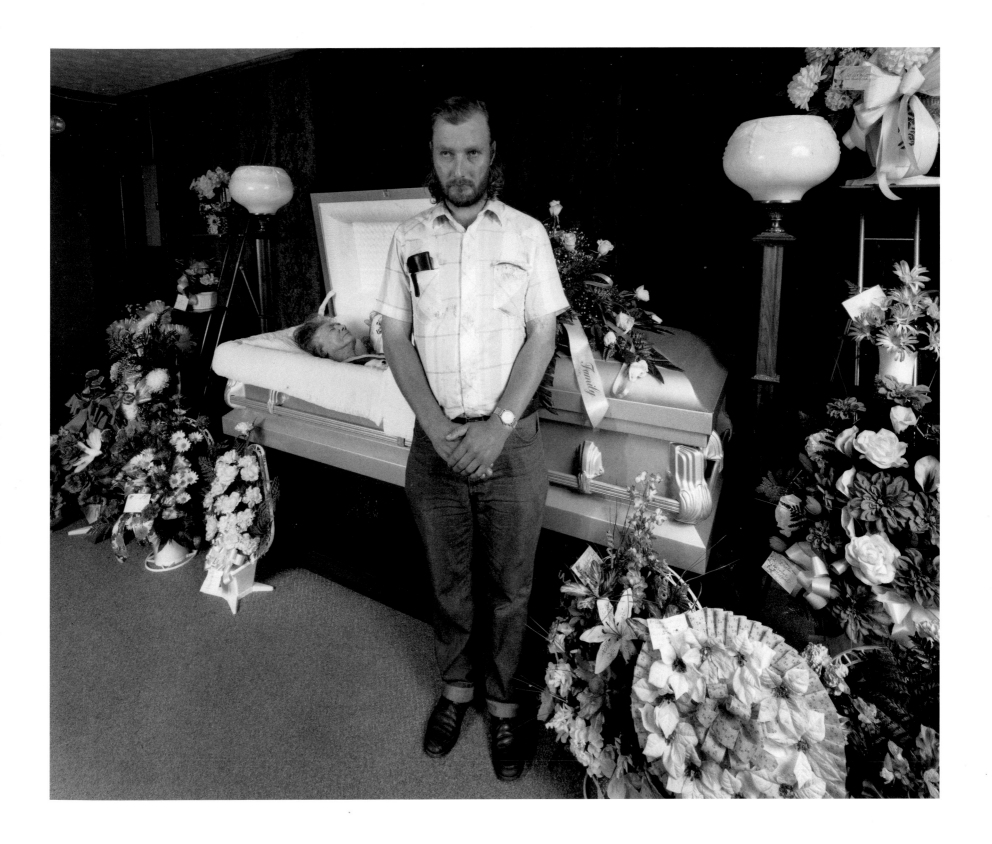

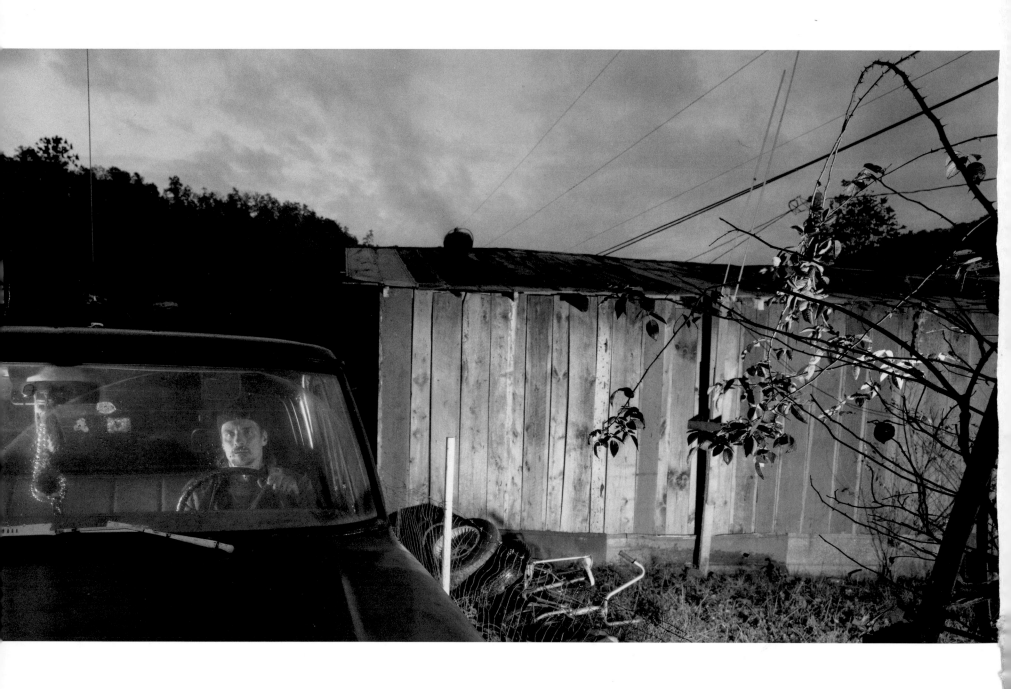

Hooterville at Dusk 1997